Provence
Sketchbook

佳佳 Ariel

Jardins du château de la Barben. 20-11-7

Front cover: Gordes, below the mountains of Vaucluse. One of the most important villages in the Luberon.
Page 3: Jouques, sheltered by the Sainte-Victoire, typifies the old Provençal hamlets.
Pages 4 and 5: To the north of Orange, enthusiasts are reconstructing stone by stone the medieval fortress of Mornas.
Back cover: Bathed in the light of the setting sun, the truncated keep at Cucuron, a tower of the kind found in every hill village in Provence.

Translation from French: Philippa Richmond

Managing Editor: Henri Julien

Illustrations © Fabrice Moireau

First published in French in 2008 by Les Éditions du Pacifique
5, rue Saint-Romain, 75006 Paris

First published in English in 2008 by Editions Didier Millet
121 Telok Ayer Street, Singapore 068590

Colour separation by Colorscan Co Pte Ltd, Singapore
Printed by Star Standard, Singapore

ISBN: 978-981-4217-67-5

Provence
Sketchbook

Paintings Fabrice Moireau Text John Burdett and Philippe Testard-Vaillant

Editions Didier Millet

SINGAPORE · KUALA LUMPUR · PARIS

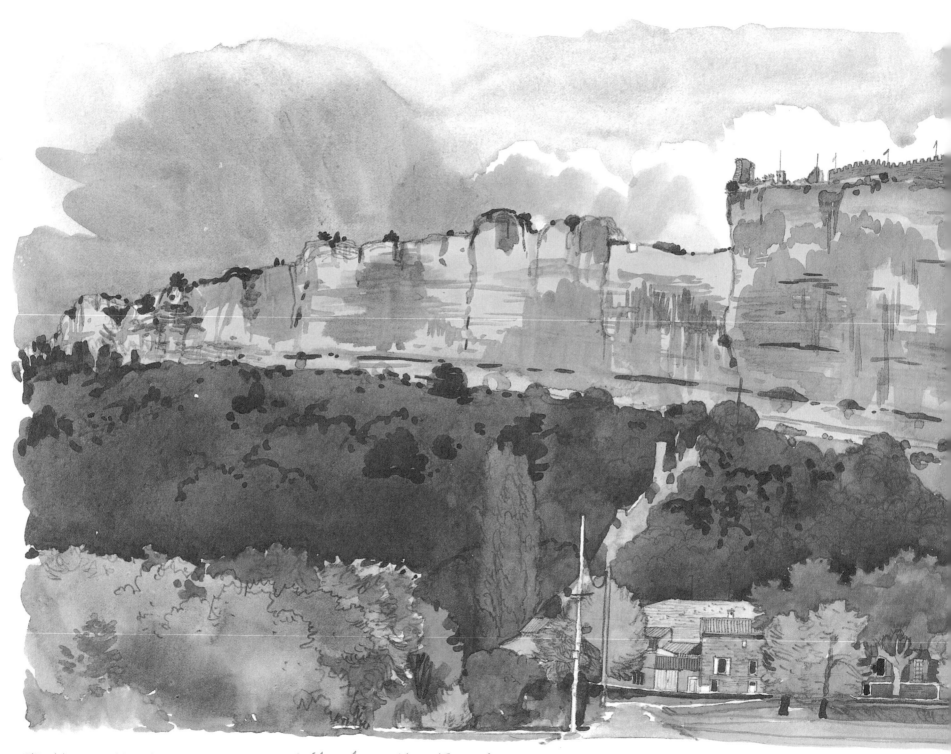

To the north of Orange and visible from the A7 motorway,
lies the medieval fortress of Mornas, lovingly reconstructed, stone by stone,
by volunteers.

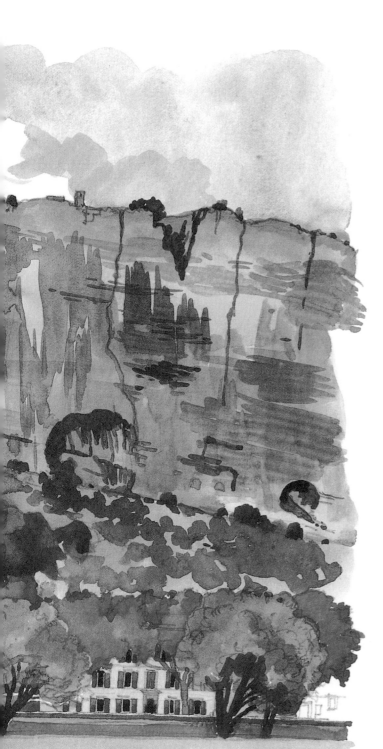

Contents

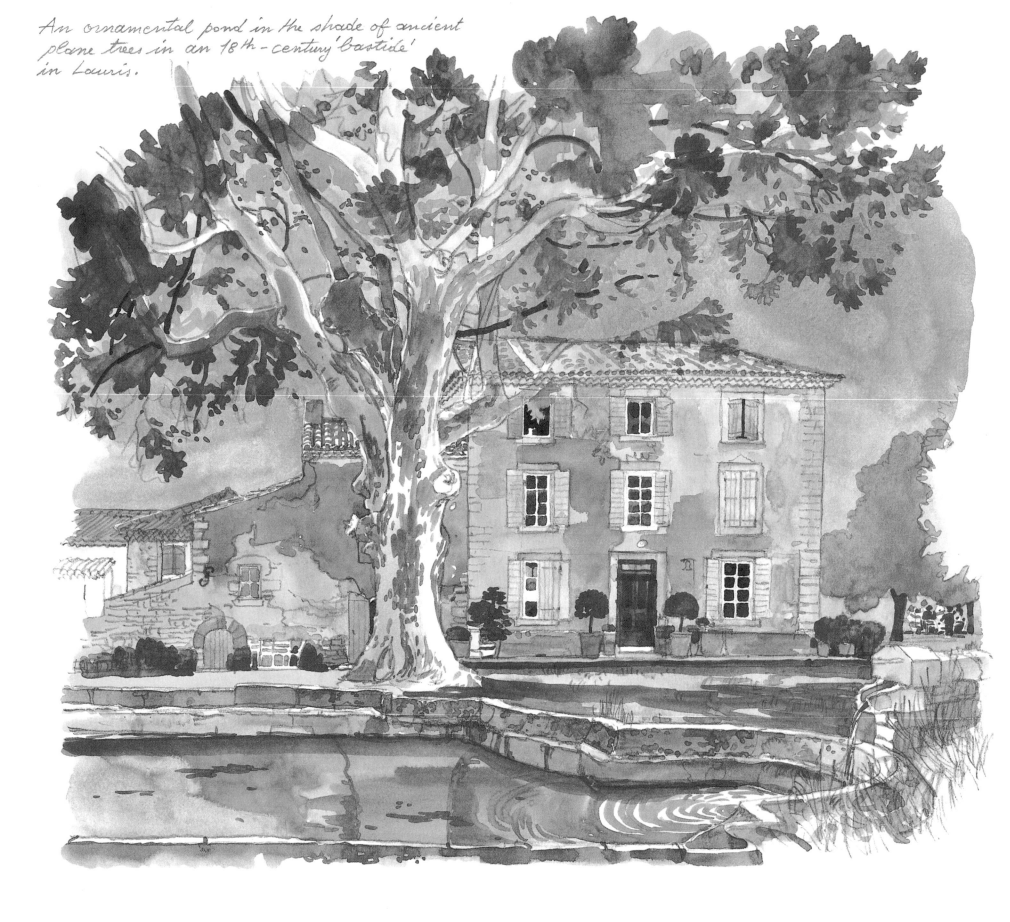

An ornamental pond in the shade of ancient
plane trees in an 18th-century 'bastide'
in Lauris.

Introduction

During those austere post-war decades before travel overseas became almost routine for us in Britain, folk memories of a more exotic, prettier, friendlier, sunnier and above all *warmer* Elsewhere lurked in the collective subconscious, and drove us slowly crazy. When they told us we could afford summer trips to that Elsewhere called France, so long as we camped, we turned the annual journey south into a national *grand prix*, which began on the first weekend of the school holidays and bestowed bragging rights on the first reckless driver to reach the Mediterranean. Amazing speeds were recorded; the BBC interviewed a man who had driven from Manchester to Cannes with his family and his 'French frame tent' in less than three days. In other words, we Brits were in the grip of one of our fads.

Mum and Dad were rather more cautious. We drove the Morris Minor on to a train at Boulogne and drove it off again at Aix-en-Provence, then continued onwards in the dark for a few more hours until we finally reached the camping site. Next morning we woke up and found ourselves in the middle of a Cézanne landscape. We all spent the day stunned, especially me. Surely this could not be real? The earth was not damp enough, the sky stayed blue for unnaturally long periods of time, the ice cream tasted terrific and it was hot. Very hot.

As a family, we quickly discovered that different rules applied in Elsewhere. Mum drank too much red wine and told dirty jokes. Dad confessed to me how sexy he found Provençal women. I discovered, decades later, that his taste in this respect exactly replicated Racine's, who described the local maidens thus to his chum La Fontaine: *color verus, corpus solidum et succi plenum*: 'natural color, firm bodies and full of sap'. We also have Racine-en-Provence to thank for an unadorned view of working class France before the 35-hour working week: 'You will see a huge number of harvesters roasted by the sun who work like demons; and, when they are totally out of breath, they throw themselves on the ground in direct sunlight, sleep for a brief moment, then immediately get up again.' Racine also offers the first recorded complaint about the cicada noise level. But it was Rousseau who really started tourism in Provence; ironically, his most influential dispatch was not about noble nature, but that most extraordinary

'Santons' (Provençal clay crib-figures) are found everywhere at Christmas time.

The Roman triumphal arch in orange (25-10 BC), one of the most beautiful examples of its kind, is now a UNESCO World Heritage Site.

The village church in Miramas-le-Vieux with its arcaded belfry.

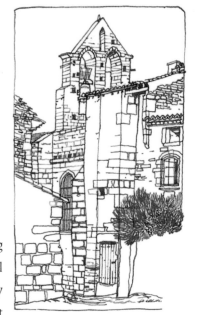

feat of Roman technology called the *Pont du Gard*, a magnificent aqueduct near Avignon, which is now a world heritage site and sees more than a million visitors each year.

So, it was all there on that first day: a canvas of infinite subtlety, complexity and history, which yet gave the appearance of simplicity. Like Racine we, too, noticed the cicadas and their legendary tendency to stop rubbing their legs together during the national lunch break, from twelve to two every afternoon. A walk to the mini-market at the camping site was an adventure in a new universe of odours: garlic, olive oil, wine, French fries. The olfactory and aesthetic references expanded greatly when we took a drive to the nearest village: fennel, dry pine, wild flowers of the undergrowth on the approach; in the cool of a village shop with massive stone walls, a stone bowl of patchouli strategically placed; houses bordered with cypress and pink laurel; a tiny restaurant with gay table cloths on which the olive oil, the bread basket, tomato, garlic and a stone jar of fresh water had already been placed. When we moved to a camping site near the sea, we found a land which in most respects had not changed since Van Gogh described it to Theo: *it's too beautiful…sunsets of pale orange turn the land blue…yellow suns hover over Provençal orchards with a monstrous gaiety…the sea is the color of mackerel, which is to say changeable, one never knows if it is green or violet, one never knows if it is blue, because the light changes in seconds and can take on a grey or rose tint.* I still remember the pine forest next to the camp, the knotted trunks of the olives bowed in the direction of the mistral and the great, Cézannesque blocks of white stone that poked through the earth.

It was a different age. The *entente cordiale* between our two countries was earthier then. Our women never stopped observing that French women didn't shave under their arms, and French women wondered why our girls didn't know how to wiggle their behinds properly. Men on both sides spent hours, sometimes days, agreeing vehemently on what bastards the Nazis were. Naturally, I fell in love with a French *au pair* as soon as we got back to London. She came from a small town near Nice and returned there for the summer. In the school library I looked up 'Provence' and read all I could find.

It did not surprise me to discover that Provence was a country long before France existed as a political entity. Its name derives from Latin: the Romans thought of it as a valuable province of Rome, partly thanks to the natural harbour at Marseilles, which was famous throughout the ancient world under the name of Marsilia; Plato, who was an olive-oil trader in his day job, may have bought and sold on the seafront there. Therefore, the Mediterranean defines the southern border, whence arrives the sirocco with its yellow dust. To the north, where the mistral starts its howling, Provence is said to begin after the Donzère Gorge on the Rhône about 60 miles north of Avignon, when the whole sky opens up to the southern light. The eastern border is none other than the foothills of the Alps; in the west the Rhône provides a natural frontier.

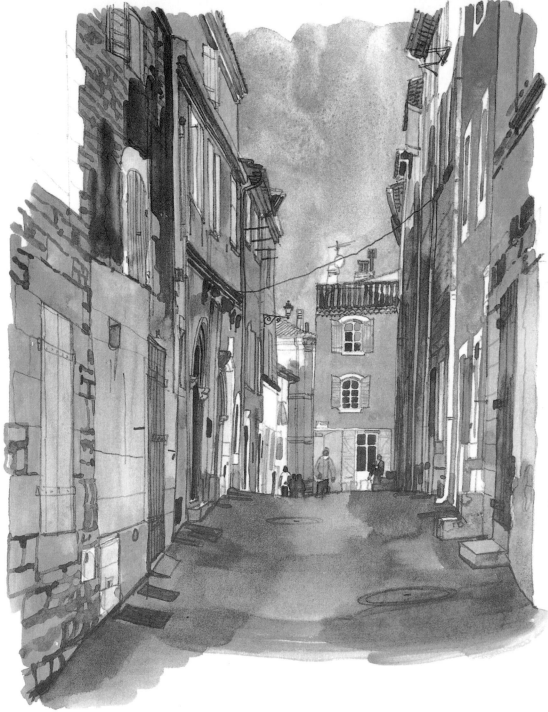

The historic part of Istres still has the feel of an old Provençal village with narrow lanes perfect for idle wandering, nowadays home to people of many different nationalities.

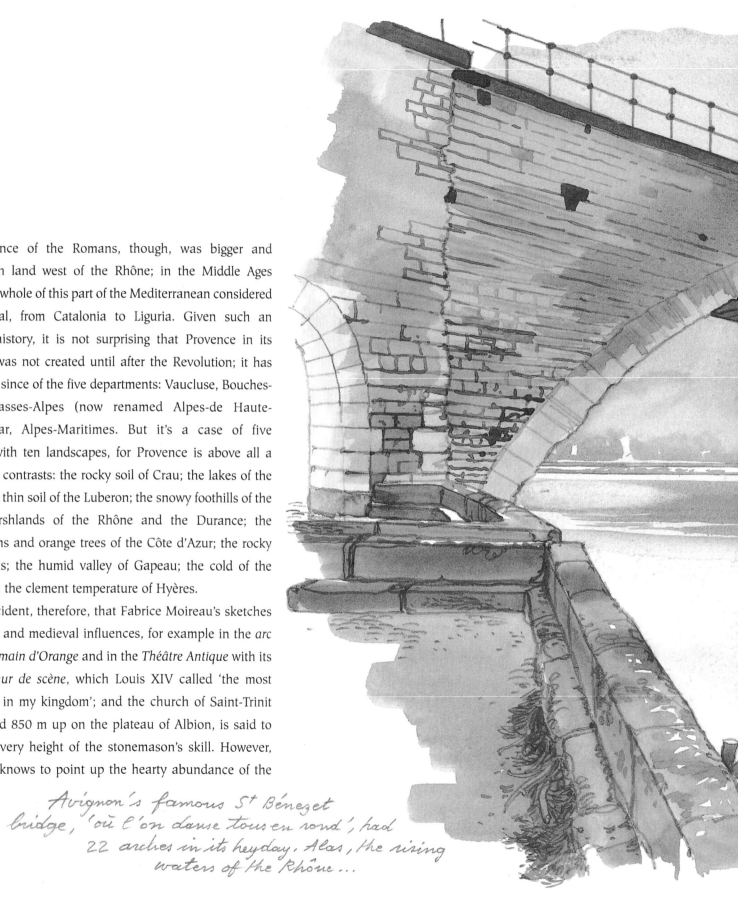

The Provence of the Romans, though, was bigger and included much land west of the Rhône; in the Middle Ages practically the whole of this part of the Mediterranean considered itself Provençal, from Catalonia to Liguria. Given such an independent history, it is not surprising that Provence in its present form was not created until after the Revolution; it has consisted ever since of the five departments: Vaucluse, Bouches-du-Rhône, Basses-Alpes (now renamed Alpes-de Haute-Provence), Var, Alpes-Maritimes. But it's a case of five departments with ten landscapes, for Provence is above all a land of abrupt contrasts: the rocky soil of Crau; the lakes of the Camargue; the thin soil of the Luberon; the snowy foothills of the Alps; the marshlands of the Rhône and the Durance; the mimosas, palms and orange trees of the Côte d'Azur; the rocky inlets of Cassis; the humid valley of Gapeau; the cold of the Verdon gorges; the clement temperature of Hyères.

It is no accident, therefore, that Fabrice Moireau's sketches reveal ancient and medieval influences, for example in the *arc de triomphe romain d'Orange* and in the *Théâtre Antique* with its magnificent *mur de scène*, which Louis XIV called 'the most beautiful wall in my kingdom'; and the church of Saint-Trinit which, perched 850 m up on the plateau of Albion, is said to represent the very height of the stonemason's skill. However, Moireau also knows to point up the hearty abundance of the

Avignon's famous St Bénezet bridge, 'où l'on danse tous en rond', had 22 arches in its heyday. Alas, the rising waters of the Rhône...

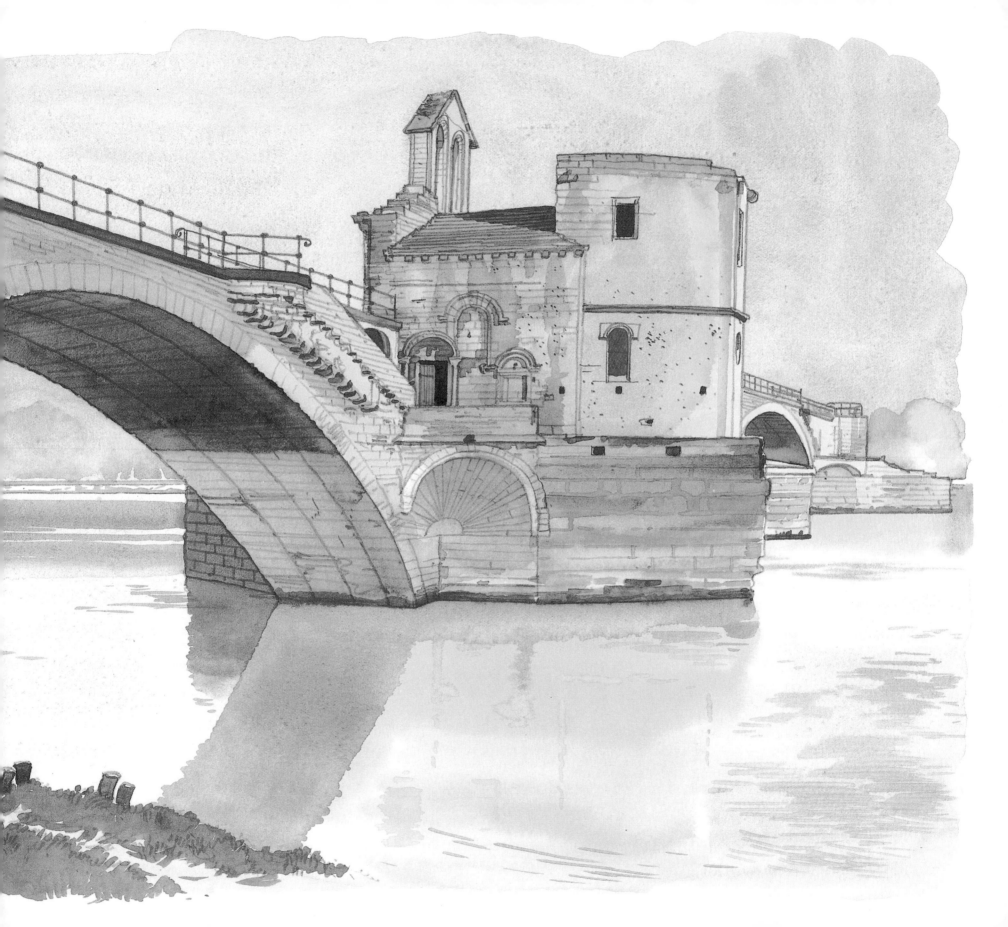

land itself, for it was not for its history that Provence was first explored by members of Louis XIV's court. From the start Provence as vacation destination was all about nature—or at least as much of it as the pampered literati could take: Madame de Sévigné, who came to live in Grignan, famously described hay-making as 'frolicking in a meadow'.

All this fascinating information caused a slow volcanic build-up during one restless London spring; I knew I was going

hitch-hiking as soon as the holidays began, whether mum and dad approved or not.

It was the mid-sixties by now. Something big was about to happen; we all felt it in our bones. A year later the cultural tsunami of '68 blew us away, with riots, wars and LSD. France that year was electric with talk of revolt; the whole nation remembered a discarded identity: nobody does revolution like the French do revolution. There was a Che Guevara with an Evita Peron in every café in Aix. In Avignon the old city walls were a perfect backdrop for beautiful young orators with black beards and shining eyes. I understood on that trip that revolutions were created so the various French classes could talk to each other again, just like under Danton and Robespierre. As in 1789, the moment was an orgasm of language, as if someone had finally got the cork out of the national fizz bottle and now everyone wanted some. Precise, Latin, cutting, slicing, charming, exploding—passionate speech was *gratuit* and *partout*; everyone had someone to talk to, or at least to listen to.

Then as now, Aix-en-Provence was as good a place as any to begin exploring. It is by far the most bourgeois Provençal town; some say the old Roman part has become the 21st arrondissement of Paris. Beautiful young people with Harley Davidsons and torn denims can be found sharing themselves with the world here on the *cours Mirabeau* most weekends and

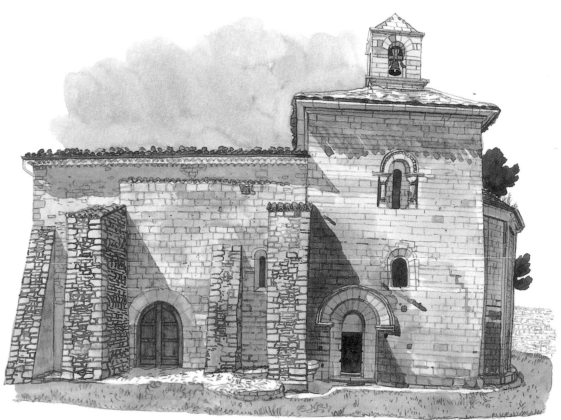

The Romanesque Eglise St Trinit perched 859 m high on the Albion Plateau.

Lavender wraps itself like blue ribbons around a cottage on the slopes of Mont Ventoux, foreshadowing the Alps.

throughout the long hot summer, while young waiters with pale complexions and black hair falling over their eyes lay out delicacies of high cuisine and the inevitable pastis with ice and water. Cézanne is so central to the identity that the mountain of Sainte-Victoire, which he painted so many hundreds of times, is often referred to familiarly as 'la Sainte'.

From Aix it is usual to follow the flow southeast to the Mediterranean and the beaches of Cassis, Cannes and Nice; but in the race for the sea we risk missing the very essence of the land. When I visit these days, I prefer to go north, to Avignon, where I once worked picking grapes as a student: I remember dawns heavy with mist; rainbows in spiders' nests; more free wine than anyone could drink. Only four of the original 22 arches are left of the famous bridge whose official name is Saint-Bénézet. Perhaps more truly emblematic of the walled town is the famous festival which takes place here every year. Its most celebrated events invariably happen in the *Cour d'Honneur du Palais des Papes*: no guidebook worth its salt will let you forget that Avignon was the papal seat and the world

centre of Christianity for a hundred years, from 1305 to 1403. And then there is the mountain.

It is often called the Giant of Provence. The official name is Mont Ventoux. It is 1912 m high—*ventoux* means windy. It can gust up to 193 mph. Tour de France enthusiasts know all about it, for the race has ascended Ventoux thirteen times since 1951; there is a memorial to the great British rider Tom Simpson who died on the peak from heat exhaustion in 1967.

Associated with the Mont is the *dentelles de Montmirail*, a curious rock-structure (best viewed from the tiny village of Suzette) which resembles lace, hence the name. But this is a country that merits so much more than mere sightseeing. For here is the centre of the Provençal herb legend where the earth is

blue for miles around, thanks to a famous wild shrub: Sault is the biggest lavender market in the world, and all the dry, special, herbs intrinsic to French country cooking are at their best and most sought-after here. And it was here, in the heart of the Drôme, as the area is also known, that Gilbert Ducros founded his spice business which quickly grew into a national cult, thanks to his telegenic genius.

From Cavaillon you can strike due south from Carpentras or follow the Durance from just below Avignon. If coming from Avignon, literary pilgrims might pay a visit to Châteauneuf de Gadagne, where Frédéric Mistral and his friends worked at reviving the Occitan tongue, constantly reminding anyone who would listen that Provence was a country and a linguistic centre all on its own. But for most French people Cavaillon means melons. Everyone here is an expert. The most important factor is the weight: the heavier it is, the sweeter and juicier; if it is to be eaten the same day then the stem must be cracked and ready to fall off.

We are in the heart of the Luberon now, whose southern boundary is the Durance river. This is the very Provence of which the troubadours and Ezra Pound sang: *I am homesick after mine own kind / and ordinary people touch me not*; and it may be no accident that so many modern-day artists and poets visited, admired and sometimes stayed in this corner. Nicholas de Staël loved it; Picasso bought a house here for his lover Dora Maar; Albert Camus bought the Château de Lourmarin in 1958 with the prize money from his Nobel prize (his body lies in the local cemetery). Giono spent almost all his life here.

If those names mean little to modern English readers, how about Peter Mayle? His book *A Year in Provence* details the fun and tribulations of twelve months in the Luberon, and, through a set of tones, signs and symbols understood only by Anglo Saxons, transmits to the cognoscenti the secret knowledge that rural Provence is the new Elsewhere. Mayle also gives an important, if *sotto voce*, reassurance that you don't need to speak the language to live there and the French might be okay after all. The result was a huge hike in real-estate prices throughout the region. *Paysans*, deeply attached to *le terroir*, turned into property developers overnight when they learned how much *les pigeons anglais* would pay for a house built on a rocky little triangle of it, so long as the house included a swimming pool. Nevertheless, there remain today many unspoilt picture-perfect villages and hamlets throughout the Luberon; Roussillon probably provides the best starting point with its famous ochre earth contrasting with the deep green of the pines.

However, nobody who has ever admired a Van Gogh leaves out Arles and the Camargue, which sit at the mouth of the wild

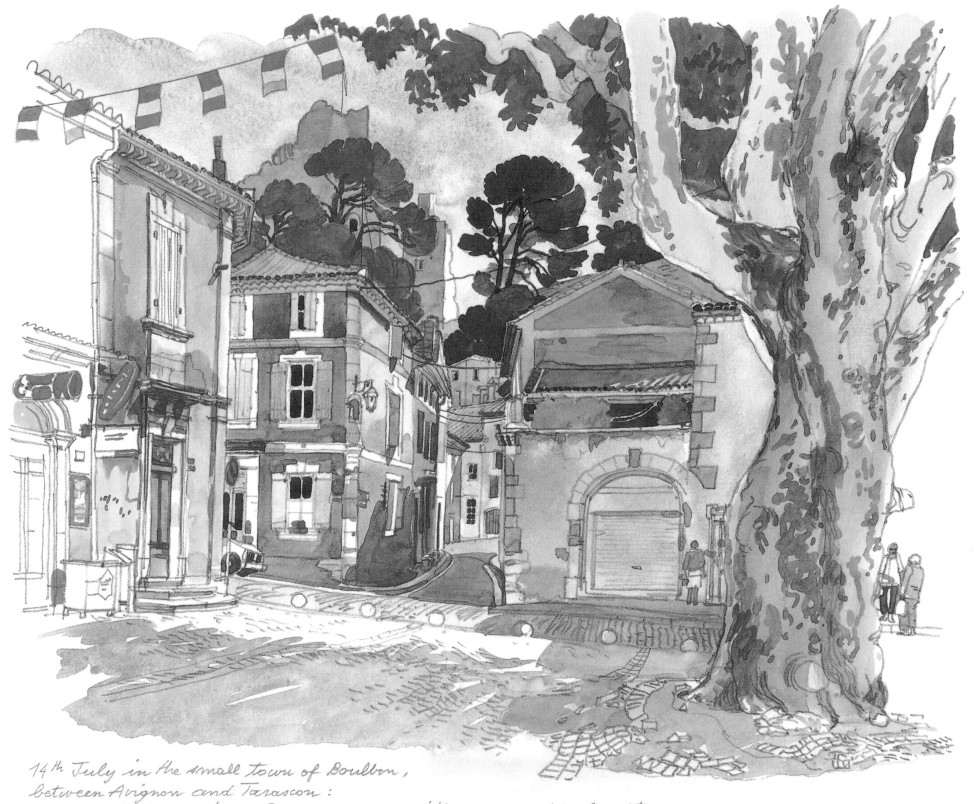

14th July in the small town of Boulbon,
between Avignon and Tarascon :
a quintessentially Provençal scene with century-old plane trees and
steep lanes bedecked with tri-coloured pennants against a
backdrop of pine-trees.

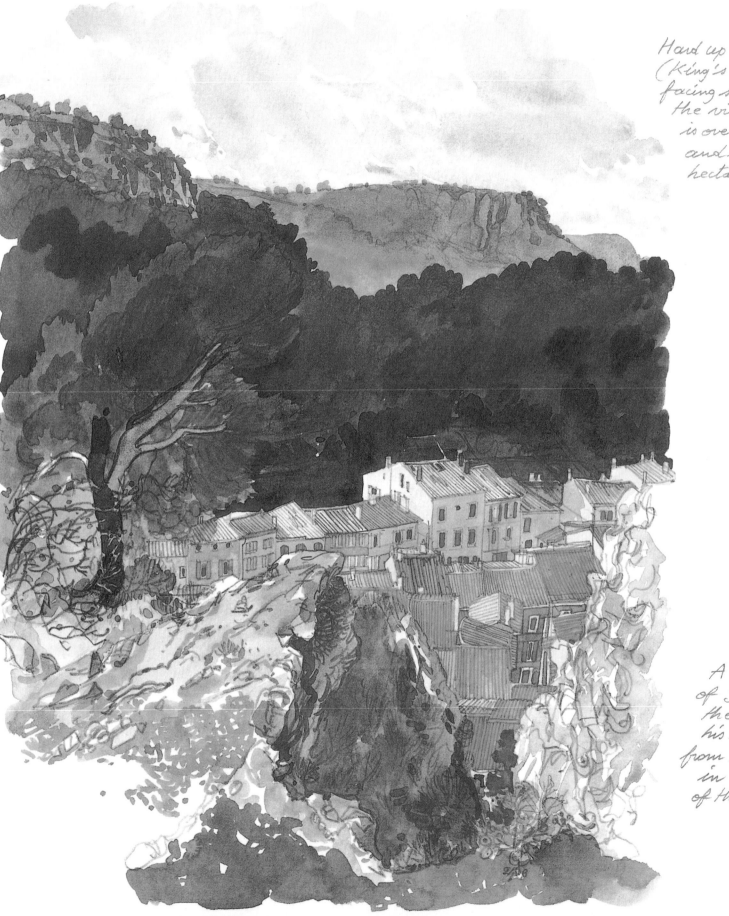

Hard up against the Pilon-du-Roi (King's Crag) on the north-facing slopes of the Étoile range, the village of Simiane-Collongue is overlooked by Castrum rock and surrounded by a 2,400-hectare forest of Aleppo pines.

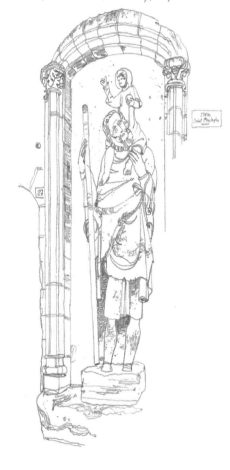

A 14th-century statue of St Christopher with the infant Jesus on his shoulders looks down from the façade of this house in Boulbon, in the heart of the Montagnette.

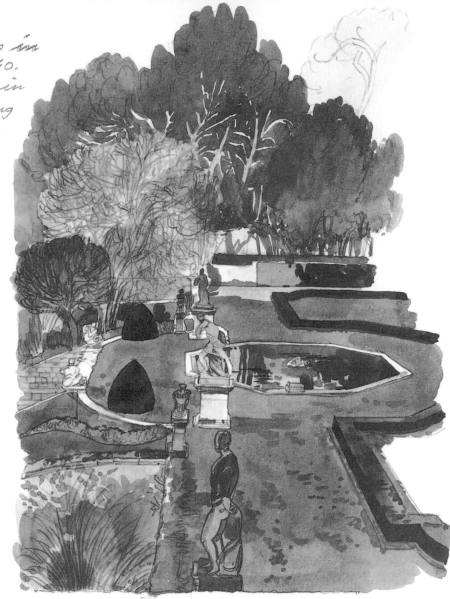

frothing Rhône. With an area of over 930 sq km (360 sq miles), the Camargue is western Europe's largest river delta (technically an island, as it is surrounded by water). It is a vast plain comprising large brine lagoons or étangs, cut off from the sea by sandbars and encircled by reed-covered marshes which are in turn surrounded by a large cultivated area.

Pinioned between the two great arms of the Rhône, Arles belongs to an immense alluvial plain, a still-wild world under a sky even more turbulent in winter than during the summer mistrals; it is all about lakes and ponds, meadows, reed beds, rice fields, pink flamingoes, egrets, and plenty of mosquitoes. The celebrity, down here, though, is the black bull of the Camargue, who exacts a religious respect from the locals

Paris was a tribal village when Phoenician sailors established Massalia on the southern coast of France during the 6th century BCE. Lawrence Durrell spent the last 20 years of his life at Sommières, not far from Avignon, where he was the first of modern English writers to give full justice to ancient Provençal history in Caesar's Vast Ghost. After the discovery of the ancient Greek ramparts in 1967, André Malraux, then Minister of Culture, forced the Mayor of Marseilles to postpone redevelopment of the stock-exchange area of the city for four years; the ramparts were said to be as important archeologically as the ruins of ancient Carthage.

Some claim that Mary Magdalene and Lazarus landed very close to Massalia two thousand years ago at Saintes-Maries-de-la-Mer, and converted the whole of the local population to their new religion. My own arrival by sea was a little different. It was 1969, the song *A Whiter Shade of Pale* haunted the long hot summer spent hitch-hiking by the sides of roads with names that began with *route nationale* and led inexorably south, in the

Built on a rocky outcrop in the Drôme, Grignan's impressive castle was, in the 17th century, home to Madame de Grignan, daughter of the Marquise de Sévigné.
Since 1996, the village has hosted an annual Festival of Correspondence in memory of these two ladies of letters.

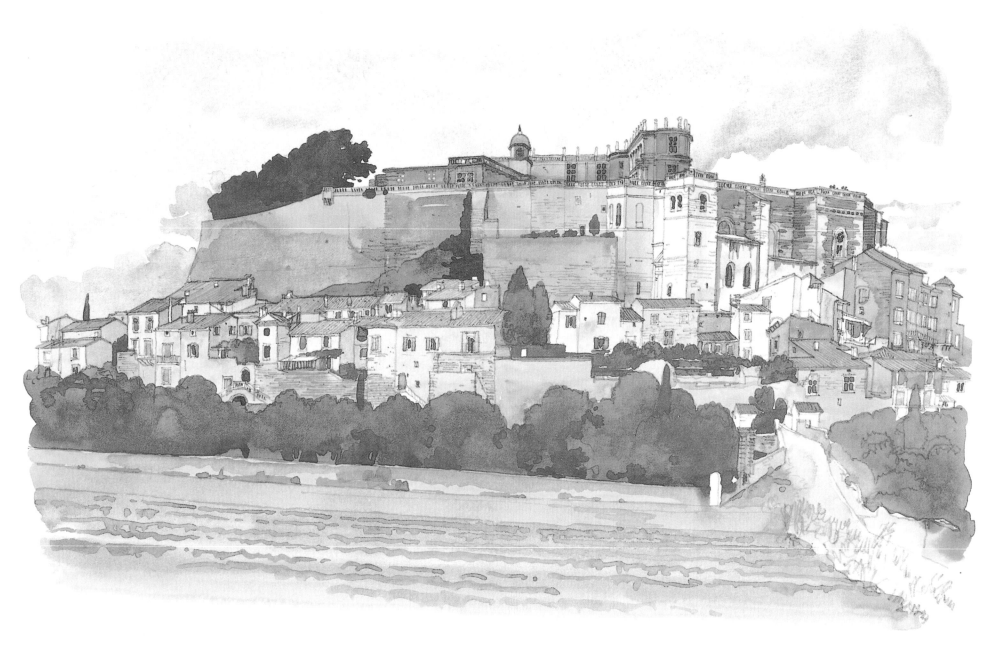

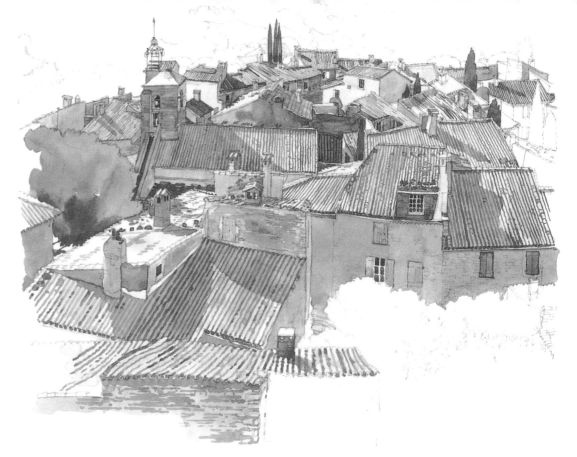

The tiled rooftops of the village of Le Barroux form a harmonious scene, unchanged for centuries, at the foot of the Dentelles de Montmirail. One of the highlights of the Provence hinterland.

company of people who belonged to the transient new race of humans called Hippy. I spent two days with a gigantic black New Yorker who carried a double bass on his back. In Tangier I smoked kiff with a deaf and dumb Moroccan albino at the Café Baba, which looked over the old city. On the way back I shipped fourth-class on a boat bound for Marseilles; the food, always rice with fish, was served from a plastic trash bucket by a black bosun who spoke gutter French. At the port, when I tried to hitchhike out, gendarmes came in a blue van and spoke to me. 'We are not here to arrest you,' they explained, 'we are here to save your life.' One of them gave me 20 francs to take a bus. He pointed to my right thumb and said: 'Not in Marseilles,' just as someone says: *Not in Chinatown*, in Polanski's film of that name.

Today, France's second city is fraught with contradictions as it struggles to maintain its many identities: largest commercial port; industrial centre; immigrant centre; holiday destination; pleasure-boat port; traditional fishing harbour; world architectural site. Traffic and pollution have taken their toll, but after years of decline, the city's fortunes picked up with the development of the TGV, the high-speed train which makes it possible to reach Marseilles from downtown Paris in three hours. Everyone's favourite beach at Cassis is half an hour by train from the city (Frédéric Mistral said: *if you've seen Paris but not Cassis, you've seen nothing*), so it really is possible to leave work at five

pm on Friday and be at a café on one of the finest beaches on the Mediterranean before dark during the summer. At the *vieux port* fishermen still dry their nets on the quays and you can buy from the morning's catch out of crates of squid, mullet, and anything fishy to go in soup. Those most interested in the human face of history will want to spend time in the *Panier* quarter, next to the port, where modest buildings represent 'the Old Marseilles' of living memory, in which countless waves of immigrants from all over Europe and north Africa sought refuge and a new life for hundreds of years. Art lovers will find themselves in a golden triangle here, with the Picasso museum in the *Château Grimaldi* at Antibes, the *Musée Matisse* in Nice and, of course, the *Atelier Cézanne* at Aix, although for some the height of the trip can only be the *jardin d'été* and the Café van Gogh in Arles.

Orange, Ventoux and Haute-Provence

As the lonely silhouette of Mount Ventoux sharpens, so do the fragrances of the garrigue and of Provence itself. Once at the foot of Mont Ventoux—a vast mineral barrage obstructing the horizon—Petrarch's first ascent in 1336 comes to mind. You feel almost compelled to follow in the footsteps of this great peer and rival of Dante, scaling the flanks of this colossus—classed as a biosphere reserve—feeling its ineffable magnetism and losing yourself in reverie. Once at the top, so high up you feel like you could almost reach out and touch the sky, you could stay up there for years, perhaps even a lifetime or an eternity. At such altitudes, the significance of time is simultaneously expanded and reduced. Muscles aching and labouring to catch your breath, you feel on top of the world, filled with light and cleansed of all blemishes. When the 'Giant of Provence' does not have its head in the clouds, your eyes will take in one of the most spectacular views in Europe. Yes, that's Mont Blanc that you can see off there to the north, and then beyond the Ecrins and Mont Aigoual, the sinuous line of the Italian border rising above the purple hues of the Esterel and Maures massifs, the crests of the Luberon, Mont Ste-Victoire, the Etang de Berre, the Dentelles de Montmirail surrounded by the vineyards of Cairanne, Beaumes-de-Venise, Gigondas de Vacqueyras and more…

Vaucluse was the last département to be annexed by France in 1793, and is the smallest one in the PACA region, just 3,574 sq m. It is the home of lavender, responsible for its magnificent blue landscapes, and of crystallised fruits, which both Anne of Austria and Madame de Sévigné raved about, of sweet melons ripe to bursting in August, and truffles to die for (just you try to mention a broad bean and green asparagus stew with truffle juice to a gourmet!). It was the Romans who founded Arausio, later renamed Orange, famous for its triumphal arch and its antique theatre where the Emperor Augustus has stood greeting people for the past 2,000 years. Every summer the town becomes a temple to bel canto. Sitting astride the Ouvèze, Vaison-la-Romaine (formerly Vasio Vocontiorum) contains more of Haute Provence's archeological highlights, including a 2,000-year old bridge across the narrowest point of this fierce flowing tributary of the Rhône.

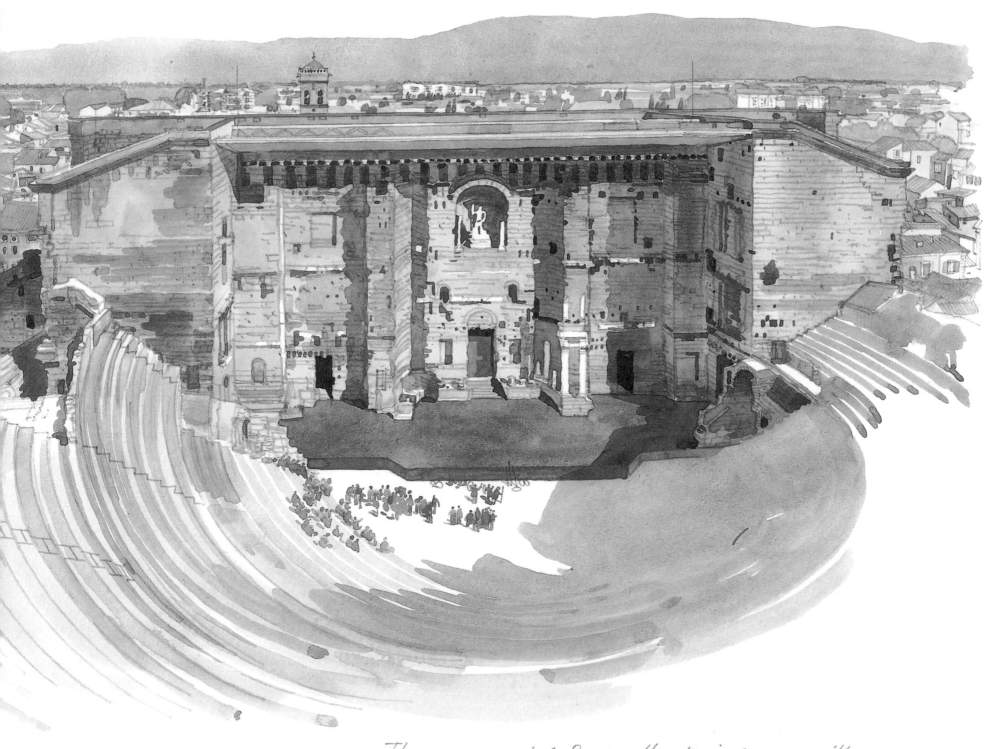

The ever-magical Roman theatre in Orange, with
its gigantic wall ('The most beautiful wall in my kingdom'
said Louis XIV). Built in the 1st Century BC, it can hold up to
10,000 spectators and has hosted the Chorégies d'Orange, a
cultural festival, every summer since 1869.

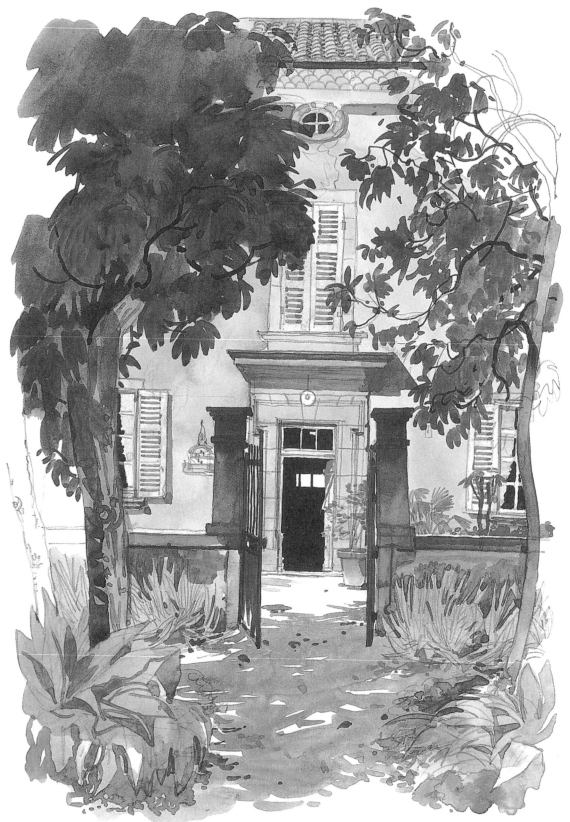

The house of
Jean-Henri Fabre
(1823 - 1915) in
Sérignan - du - Comtat.
Here's a man who spent
his life chasing after tiny
creatures!
Having abandoned
teaching in the 1870s,
the 'Homer of
entomology' spent the
rest of his life observing wasps,
cicadas, crickets, praying
mantises, butterflies, beetles,
glow-worms and
other insects.

Lyristes plebejus
(Cicada orni)

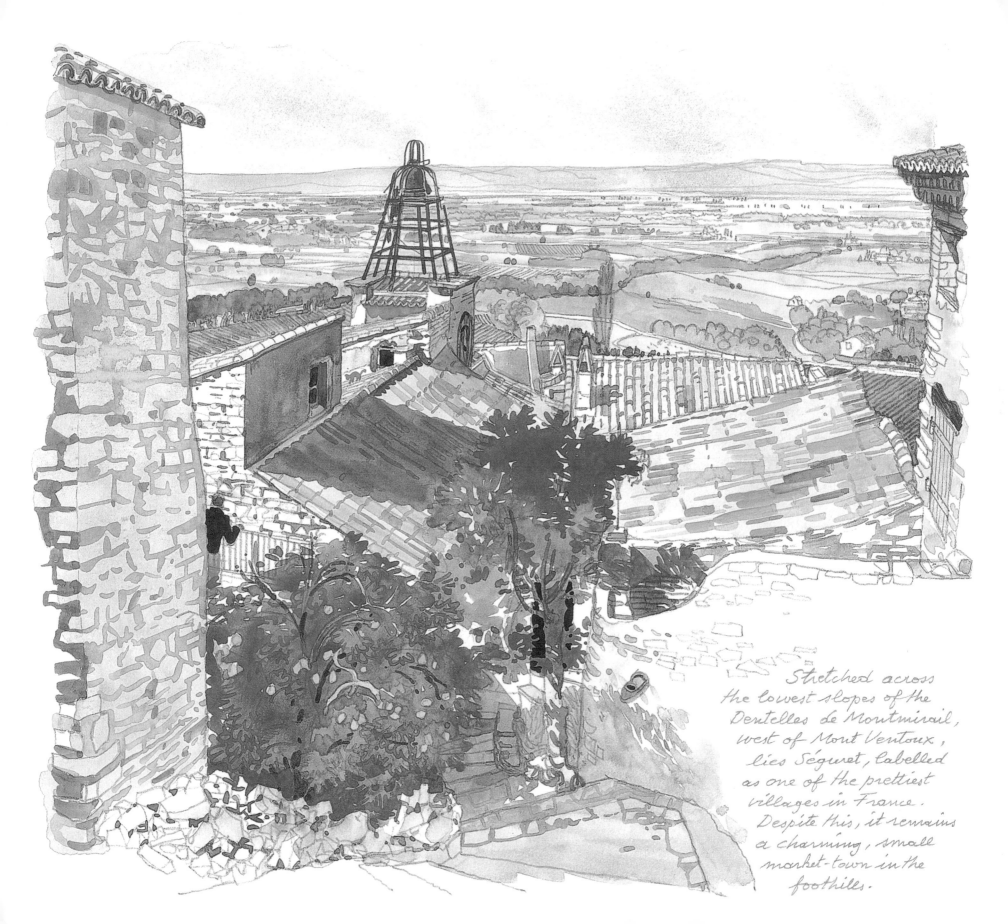

Stretched across
the lowest slopes of the
Dentelles de Montmirail,
west of Mont Ventoux,
lies Séguret, labelled
as one of the prettiest
villages in France.
Despite this, it remains
a charming, small
market-town in the
foothills.

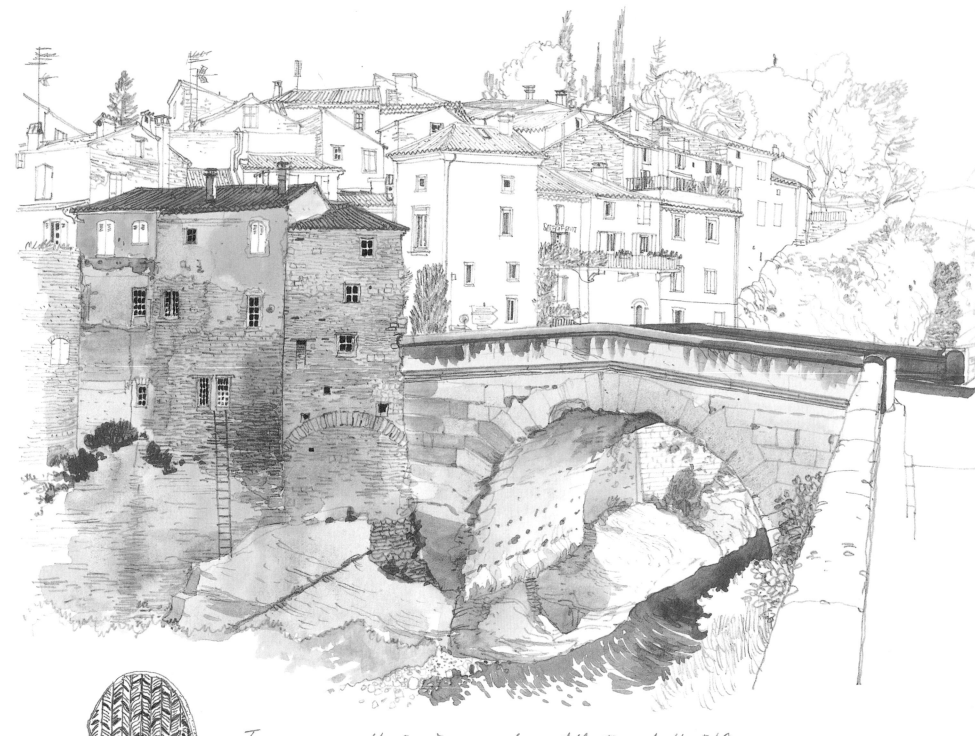

In summer, the Ouvèze, a minor tributary to the Rhône, is often no more than a trickle, but at other times it swells terrifyingly, as it did in September 1992, when its floodwaters devastated Vaison-la-Romaine. The town's Roman bridge, solid as classical antiquity itself, survived the shock, only losing its parapet.

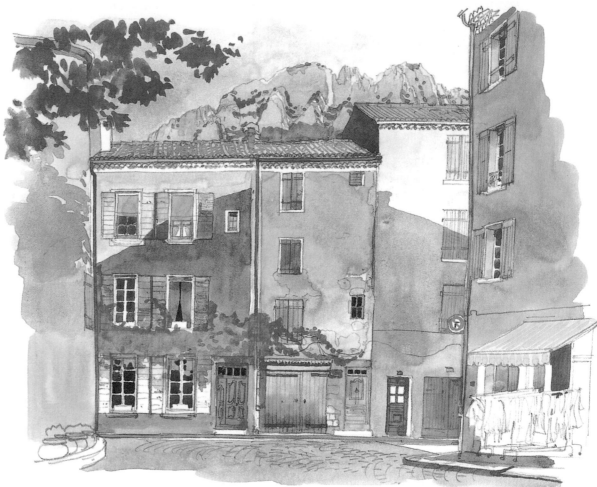

Nyons has one of the driest
climates in France and is
renowned for its market,
its 'soustets' (covered walkways)
and its black olives, including
the 'tanche'.

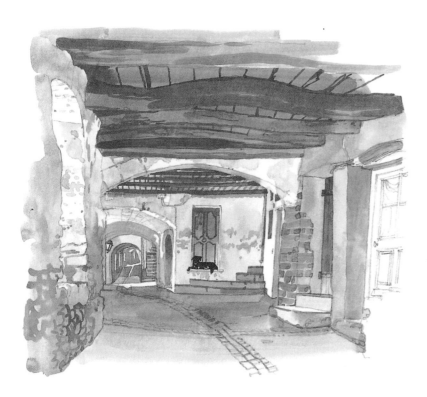

Buis-les-Baronnies,
at the foot of the
imposing Rocher
St Julien.
The surrounding
area abounds
in wild herbs.

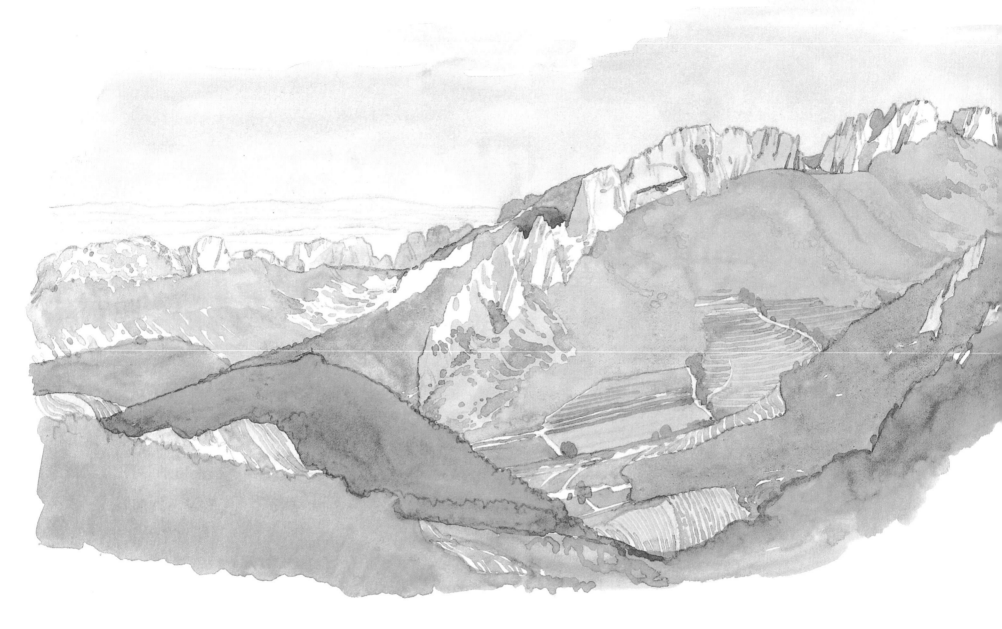

The Dentelles de Montmirail in all their
geological splendour, seen from the village of Suzette, on a
September night. Erosion has transformed this knoll
into extraordinary limestone pinnacles, much to the joy
of rock-climbers and energetic hikers.
Its lower slopes are covered in vines, grown on vast
terraces, producing some delectable
sweet wines.

The Château du Barroux,
built in the 12th century
to defend the Comtadine plain.

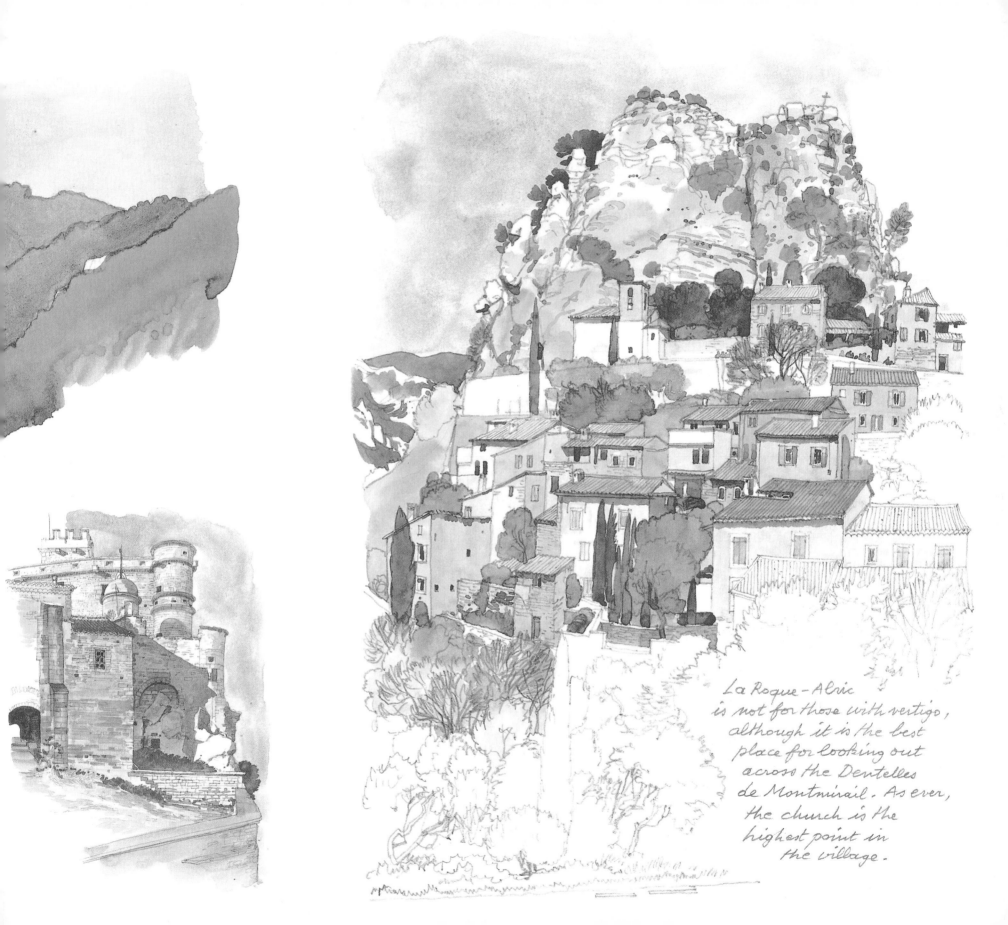

La Roque-Alric
is not for those with vertigo,
although it is the best
place for looking out
across the Dentelles
de Montmirail. As ever,
the church is the
highest point in
the village.

Situated a dozen or so kilometres to the east of Carpentras, Mormoiron nonchalantly straddles a knoll where ochre was once quarried.

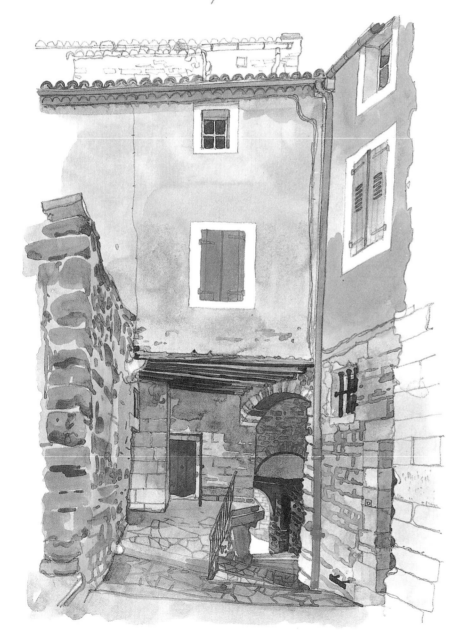

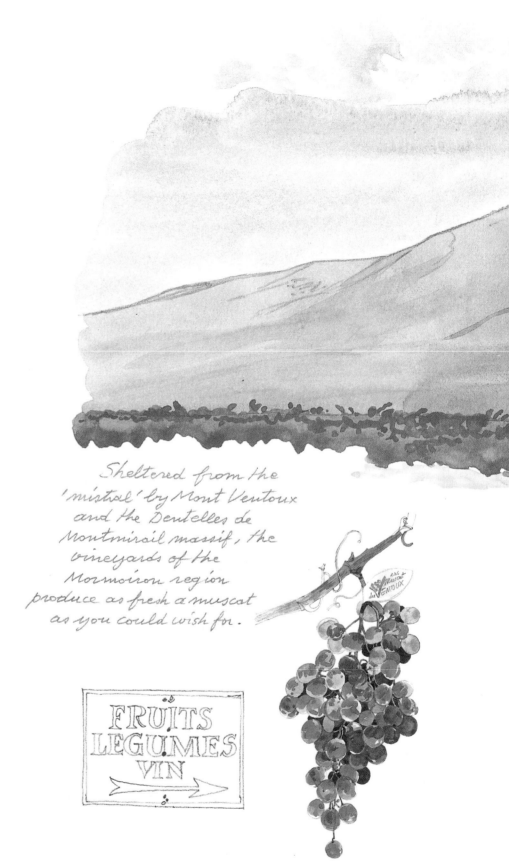

Sheltered from the 'mistral' by Mont Ventoux and the Dentelles de Montmirail massif, the vineyards of the Mormoiron region produce as fresh a muscat as you could wish for.

FRUITS
LEGUMES
VIN

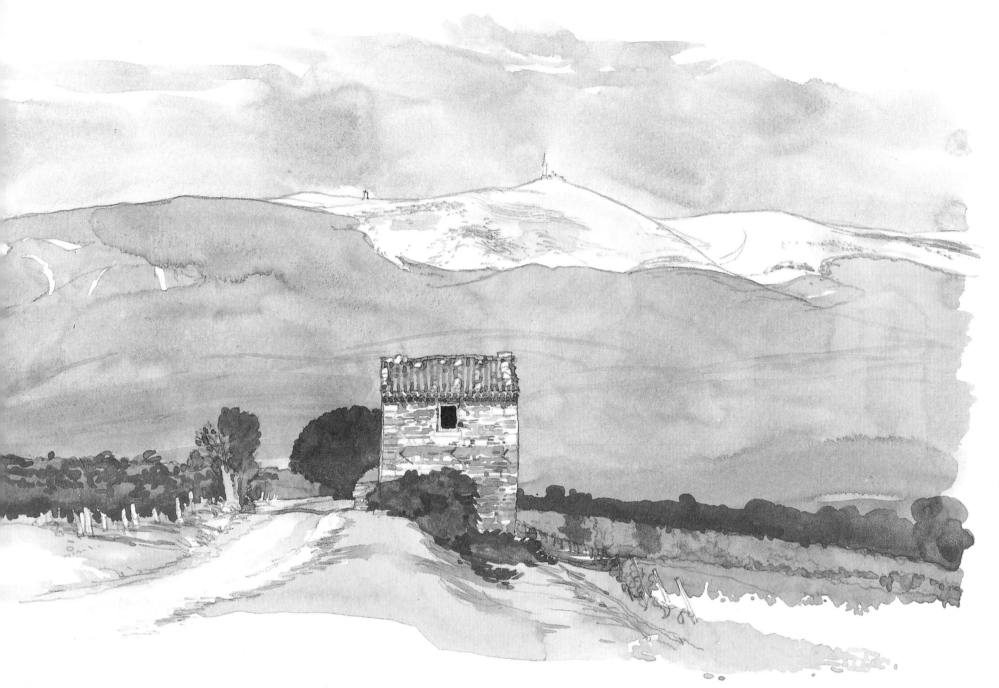

' It must be called "Ventour", as it is known
in Provençal. It is the tower of all winds, the cavern of
Aeolus,' wrote André Suarès. This is because the dome-shaped
Mont Ventoux, the only relief on the Haute-Provence plain,
visible from the sea on clear days, can howl with winds
up to 250 km per hour. A cyclist's nightmare...
Crowned by UNESCO as a Biosphere Reserve, the dark
bluish mass of this natural wonder, 1,912 m tall, dominates
the Avignon plain.

The façade of a
farm-building
in the hamlet of
Lagarde-d'Apt.

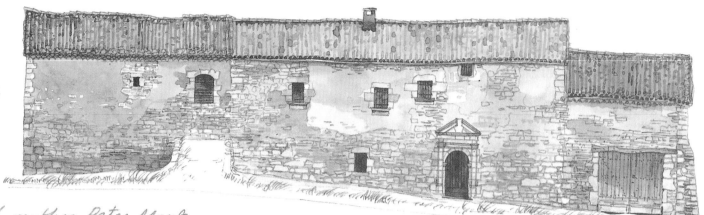

The 'Provenglais' author Peter Mayle
describes the region's 'blue gold' as
'the flag of Provence', grown in never-
ending rows in vast fields, usually with
an old building in the background
or a smiling peasant in the
foreground.

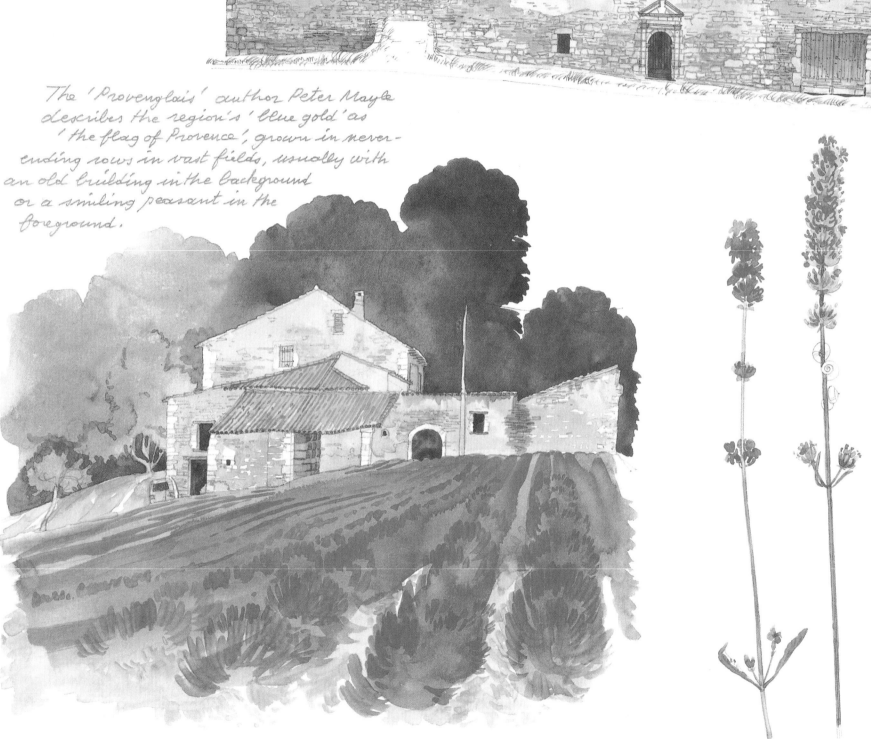

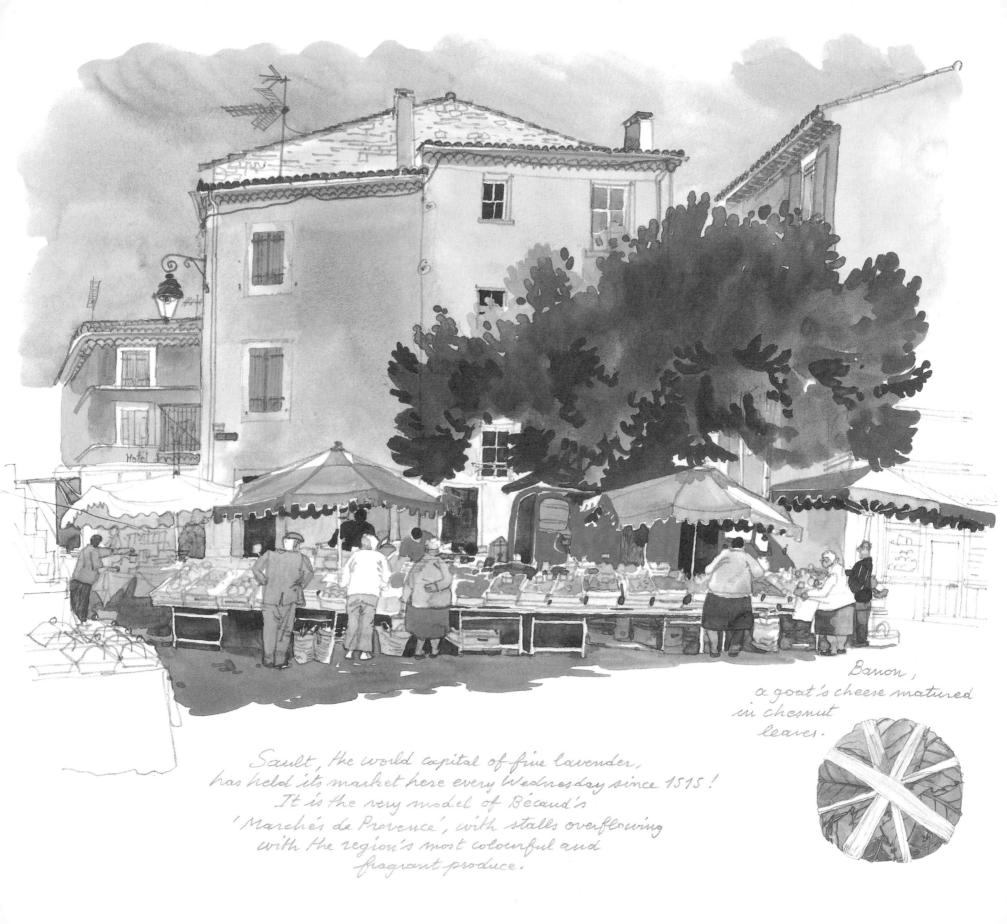

Banon,
a goat's cheese matured
in chesnut
leaves.

Sault, the world capital of fine lavender,
has held its market here every Wednesday since 1515!
It is the very model of Bécaud's
'Marchés de Provence', with stalls overflowing
with the region's most colourful and
fragrant produce.

Avignon, the Comtat Venaissin and the Alpilles

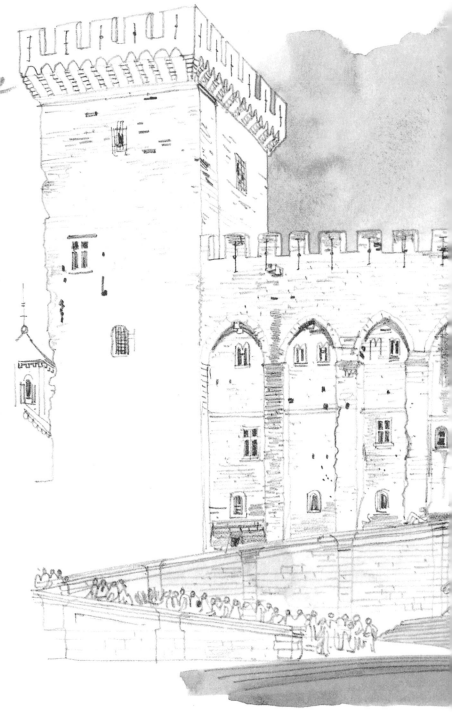

'To linger at the gates of Avignon is to linger at the gates of Paradise.' There is truth in this exaggerated saying. Overlooked by the Rocher des Doms and embraced by the Rhône, Avignon is a city whose name evokes a sense of wonder. Its fortifications, Italianate squares, UNESCO-listed palaces, clock towers and the old river surrounding it speak of that parliamentary vote which, at the start of the French Revolution, forever attached it to the French nation. Of how a city icon, a 12th-century bridge built by St Bénézet, was half-washed away by floods in 1669. Of 1309, when Pope Clement V (the first Avignon Pope) abandoned the Tiber for the Rhône, and six succeeeding pontiffs made this mistral-swept city Christianity's capital for nigh on a century.

Every summer since 1947, the former papal residence has housed one of the world's foremost arts festivals. The palace's main courtyard, the Cour d'Honneur, alive with memories of Jean Vilar and Gérard Philipe, is transformed into a stage where theatre and architectural wonder are united late into the night.

The Comtat Venaissin, south of Carpentras, has 'the most beautiful villages in France', including Venasque overlooking a sea of orchards surrounded by dense garrigue, Le Barroux atop a limestone peak and l'Isle-sur-Sorgue, the 'Venice of Comtat'. There's the Alpilles mountains, barely 25 km long and 10 km wide, the fief of Frédéric Mistral who wrote of this sun-drenched natural barrier as 'encircled with olive trees like a rocky Greek massif, a genuine belvedere for glory and legends'.

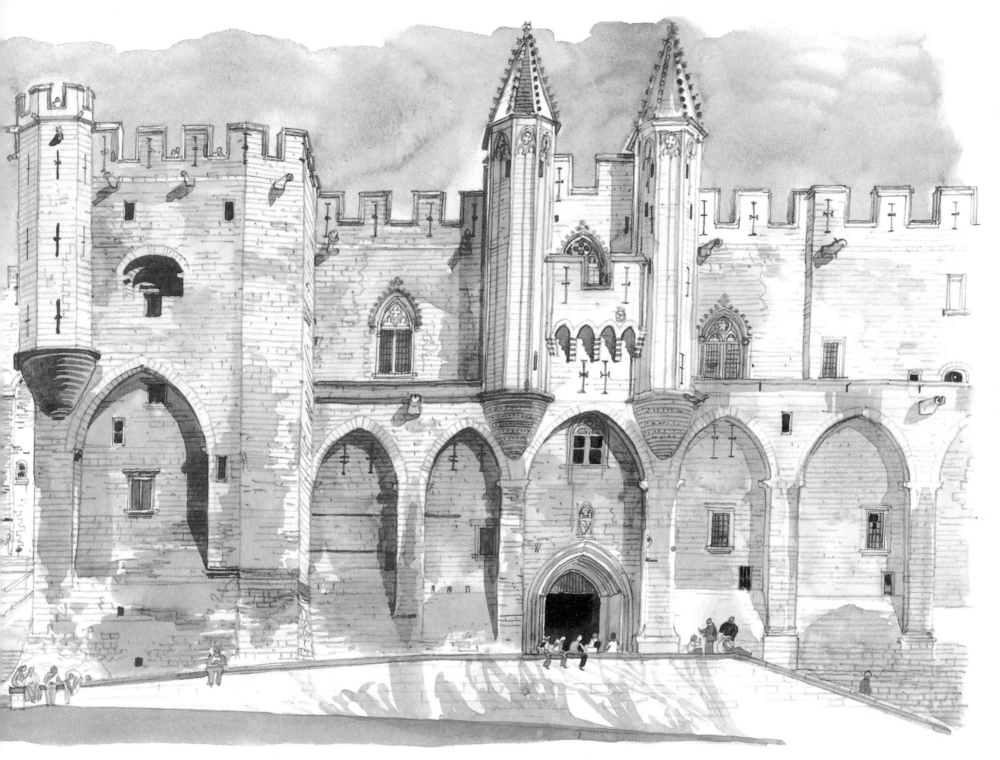

The Palais des Papes in Avignon is one of the top 10 most visited sites in France. A number of St Peter's successors resided here after 1309, when Clement V abandoned Rome, a place torn apart by the factional disputes of the city's powerful families. Protected by the Rocher des Doms, Avignon provided an easily defended site.

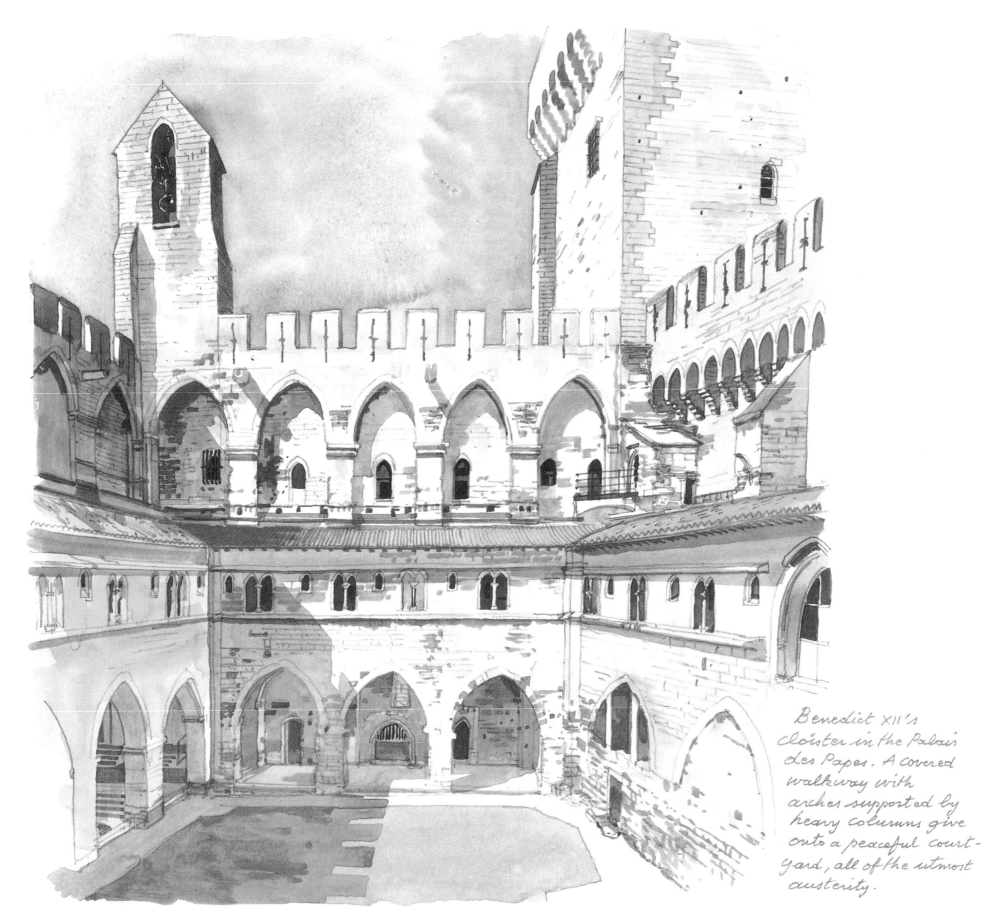

Benedict XII's cloister in the Palais des Papes. A covered walkway with arches supported by heavy columns give onto a peaceful courtyard, all of the utmost austerity.

The entrance to one of the most
magnificent palaces in Avignon,
the 15th-century Palais du Roure.
Frédéric Mistral gave it this name
('roure' means 'oak' in Provençal)
in the 19th century and made it a base for
the Félibrige, a literary movement dedicated to
the revival of Provençal, to returning the 'Oc'
language to the status it had enjoyed at the
time of the troubadours.

The Palais des Papes seen from
the Rue Banasterie in the
heat of midday sun.

The Château de Font-Ségugne in Châteauneuf-de-
Gadagne, east of Avignon, where Frédéric Mistral
(a Nobel Prize laureate for literature) founded the
Félibrige on 21 May 1854 with six young Provençal friends.
The place is not open to the public, but there's
nothing to stop you poking your nose through
the gates to muse, from afar, upon the memory
of these 'literary types' in their neck ties and
'gardian's' hat.

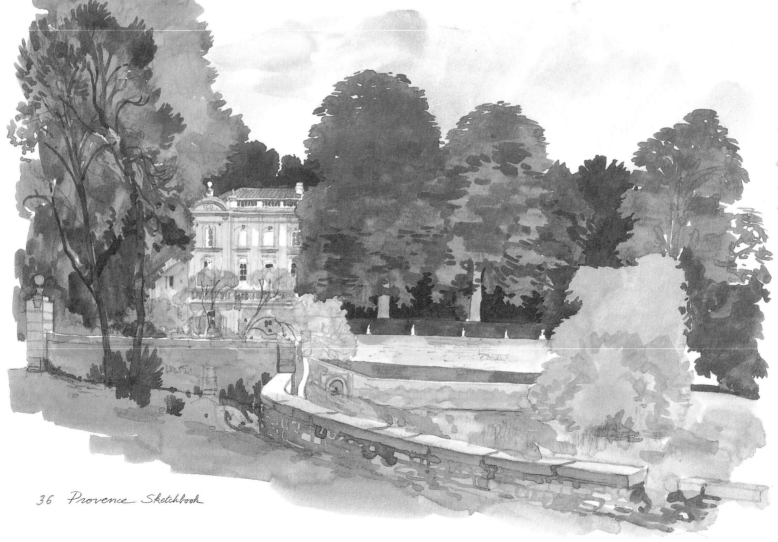

The Vallis Clausa
papermill in
Fontaine-de-Vaucluse
with its 7-m-wide
wheel turned
by the waters of
the Sorgue river.

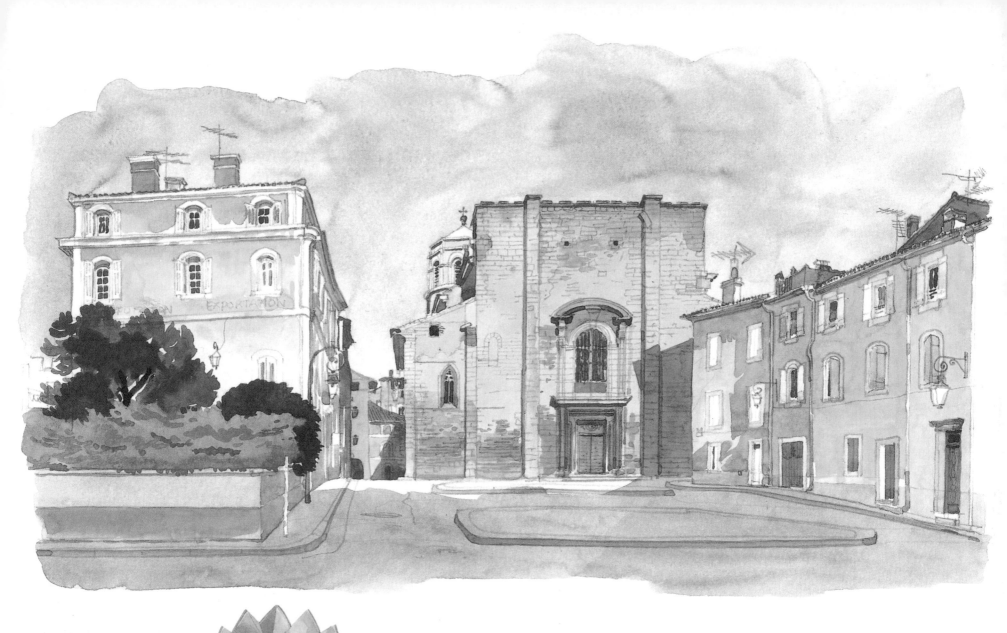

Cavaillon, the melon capital
of France, nestling between
the Alpilles and the Luberon, has a
curious dictum : ' God created the nose for putting
glasses on, and the segments of a melon, well
rounded and chubby, to help prize it open back home'.
The unadorned façade of the Romanesque Cathédrale St Véran
belies the carved woodwork within and the
charming cloister which once separated the
cathedral from the priory church.

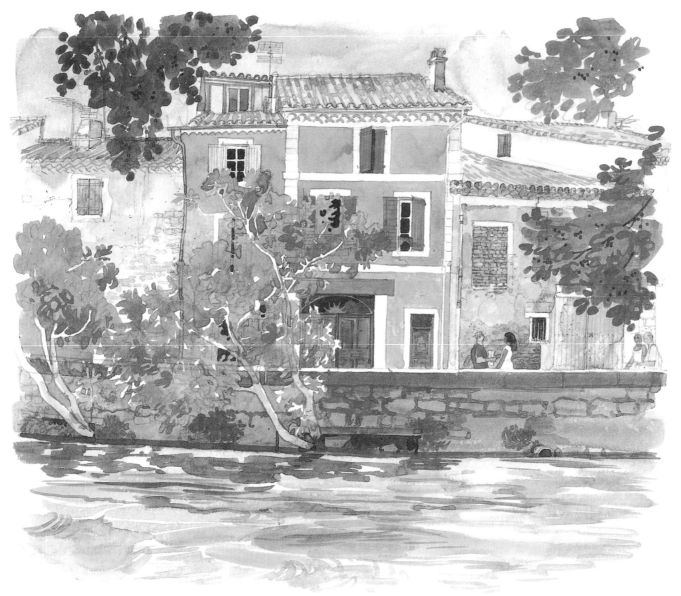

A heaven for those
with deep pockets,
the antiques fair
in L'Isle-sur-la-Sorgue
celebrated its
40th anniversary
in 2006.

Despite the continuous flow of tourists
and unprepossessing houses springing up
like mushrooms, it is hard to ignore the
charm of L'Isle-sur-la-Sorgue, the 'Venice
of Comtat', surrounded as it is by waterways!
Fans of the poet René Char,
author of Fureur et Mystère, know
of this village as his birthplace.

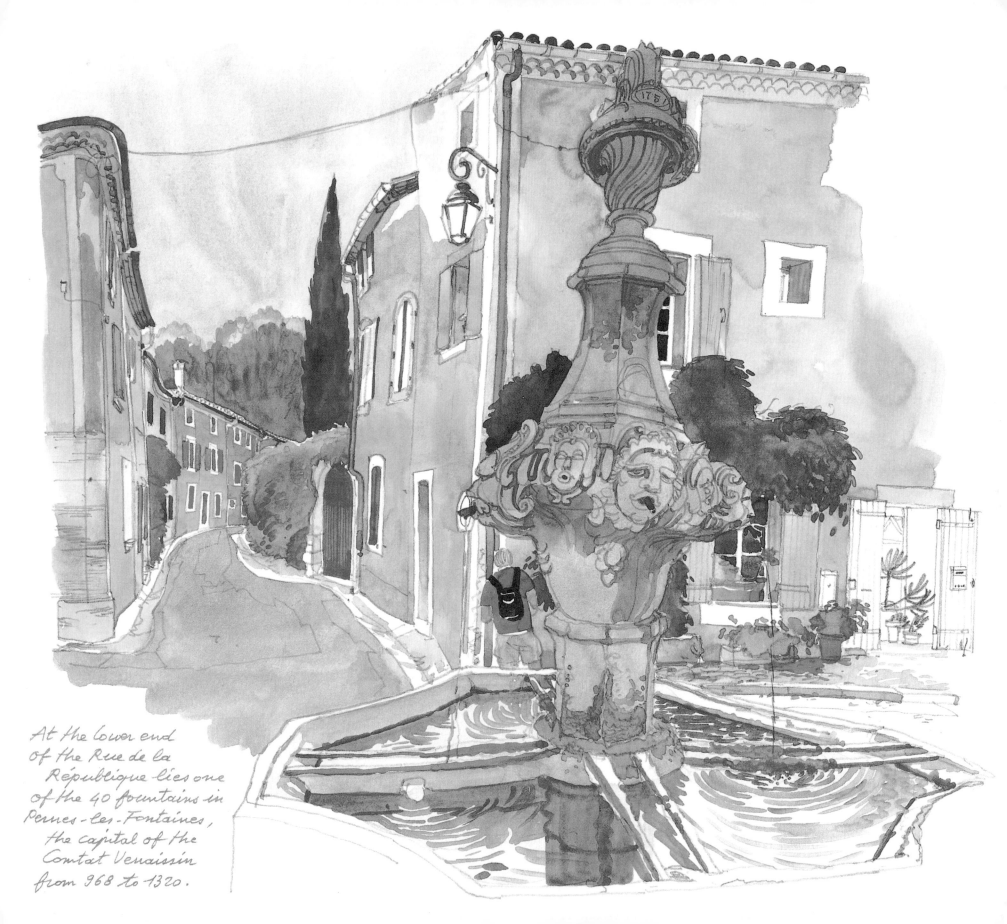

At the lower end
of the Rue de la
République lies one
of the 40 fountains in
Pernes-les-Fontaines,
the capital of the
Comtat Venaissin
from 968 to 1320.

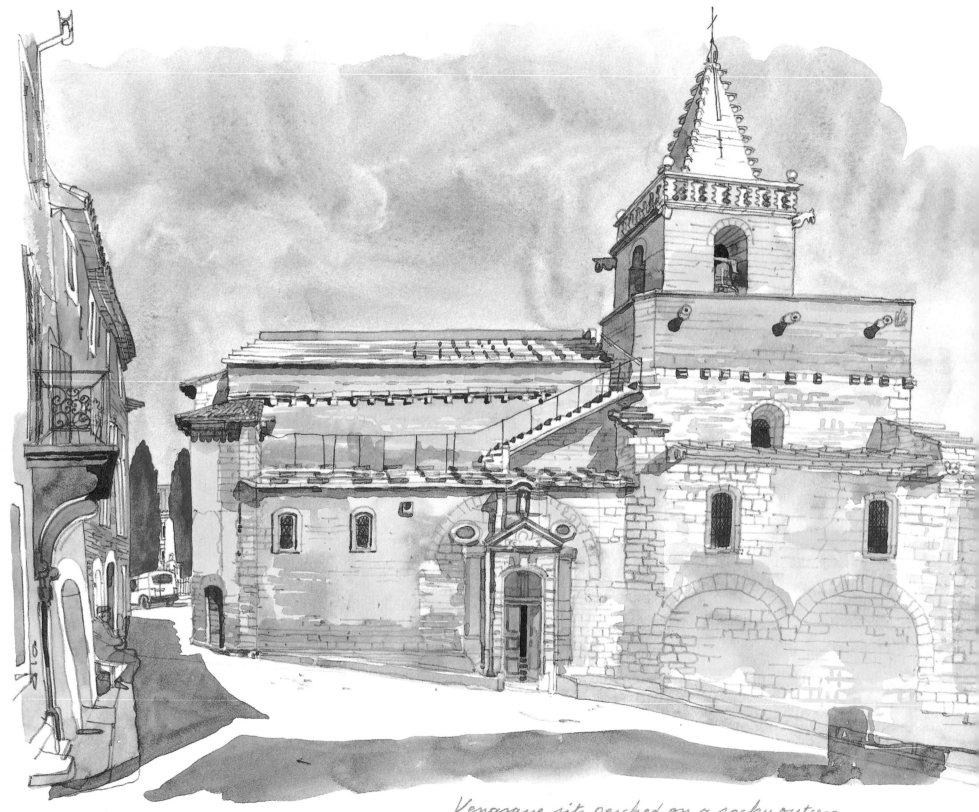

Venasque sits perched on a rocky outcrop overlooking a sea of vines and cherry trees and fragrant garrigue. Midway between Gordes and Carpentras, the village's remaining ramparts embrace the Eglise de Notre-Dame, adjoining a 6th-century baptistry built by some long-forgotten bishop.

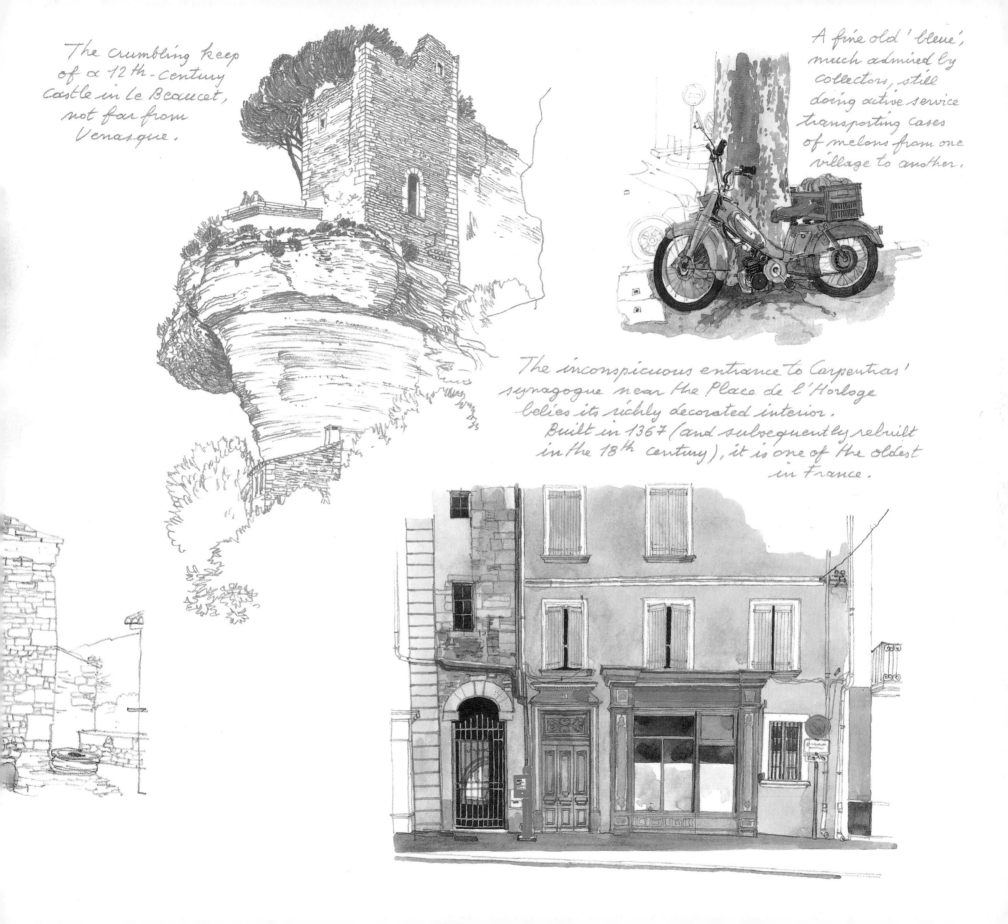

The crumbling keep of a 12th-century castle in Le Beaucet, not far from Venasque.

A fine old 'bleue', much admired by collectors, still doing active service transporting cases of melons from one village to another.

The inconspicuous entrance to Carpentras' synagogue near the Place de l'Horloge belies its richly decorated interior. Built in 1367 (and subsequently rebuilt in the 18th century), it is one of the oldest in France.

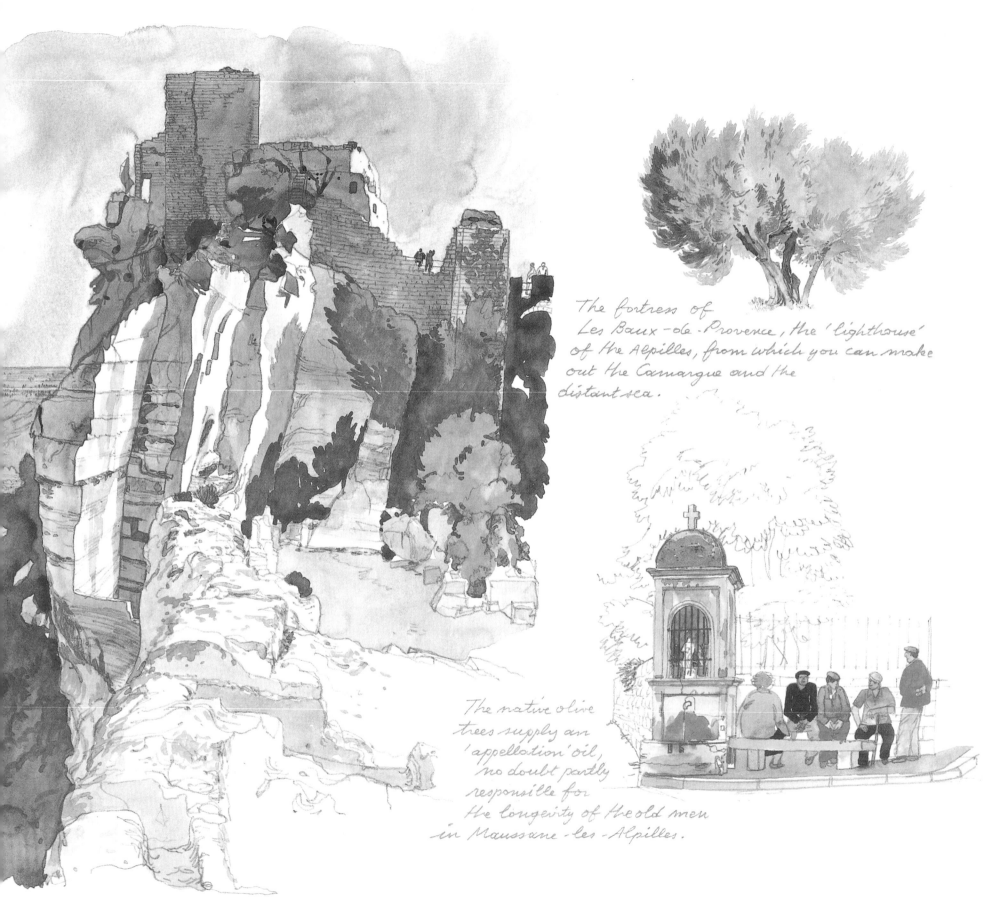

The fortress of
Les Baux-de-Provence, the 'lighthouse'
of the Alpilles, from which you can make
out the Camargue and the
distant sea.

The native olive
trees supply an
'appellation' oil,
no doubt partly
responsible for
the longevity of the old men
in Maussane-les-Alpilles.

A superb climate, sleepy squares exuding nostalgia
with venerable 2CVs resting peacefully, hidden lanes filled with fragrances
of Provence and a hinterland depicted by Van Gogh in over 150 canvases –
all of this and more up in St-Rémy-de-Provence, a place where
living well comes easily.

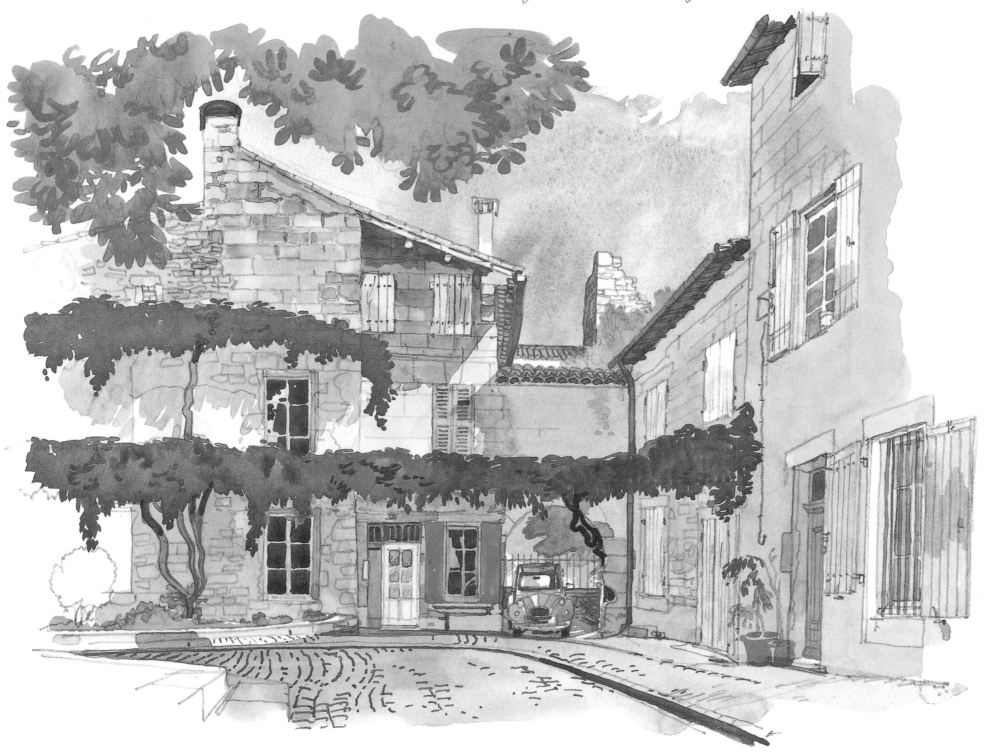

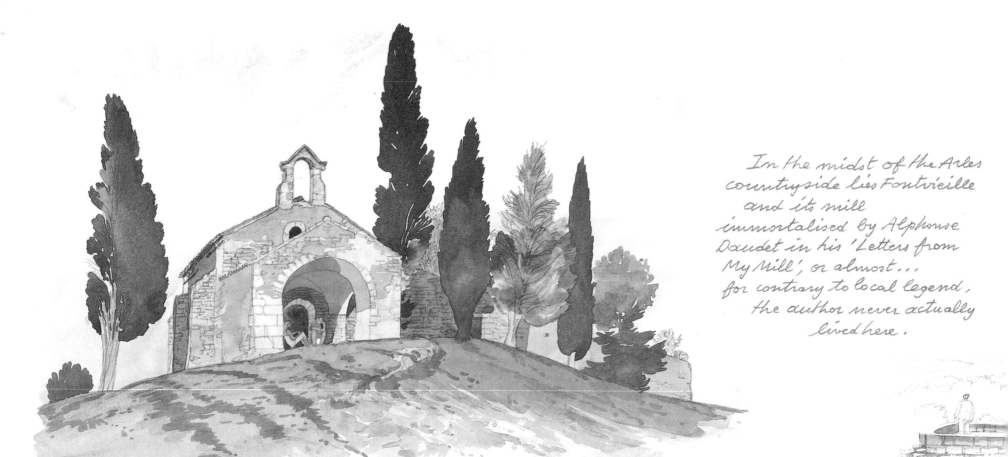

In the midst of the Arles countryside lies Fontvieille and its mill immortalised by Alphonse Daudet in his 'Letters from My Mill', or almost... for contrary to local legend, the author never actually lived here.

The well-preserved 12th-century Chapelle St-Sixte in Eygalières, a small town situated on the north side of the Alpilles range east of St-Rémy-de-Provence.

A wall of tall cypresses shelters the village of Maillane from the 'mistral'. A paradise to be protected at all costs.

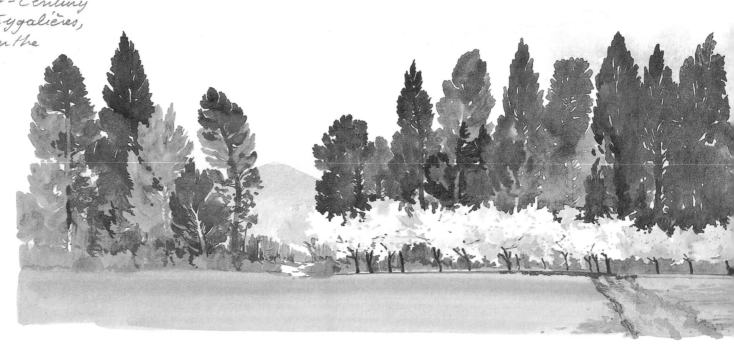

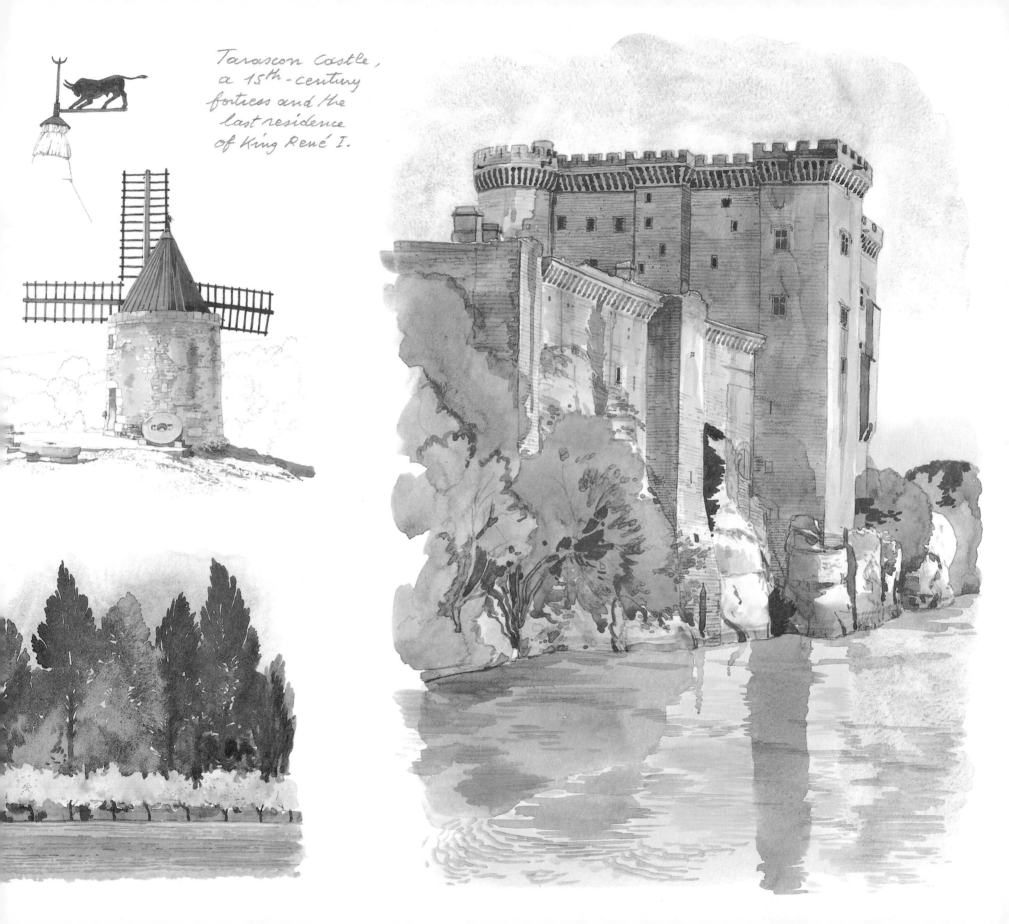

Tarascon Castle,
a 15th-century
fortress and the
last residence
of King René I.

Luberon and the Durance

Talk to a demographer and he'll tell you that a growing number of young working people are settling in the Luberon and breathing new life into previously deserted villages. Estate agents will tell you that (thanks to high-speed train links) more and more Swiss, Irish, English, Belgians, Dutch, Germans and Luxembourgers are buying holiday homes in Gordes, Ménerbes, Lourmarin, Lacoste, Goult and so on. At present, a simple house with garden in the area between the Calavon plain and the Durance valley costs a small fortune.

Historians will tell you that Luberon was called 'Lebredo' in the Middle Ages; naturalists will proudly talk of the Bonelli's eagles that circle high above the 165,000-hectare regional nature park straddling the Vaucluse and the Alpes de Hautes Provence; gossip columnists will spill the beans on the jet set who come here to work on their tans. Faced by these wild and mountainous landscapes with villages perched on high, the philosopher holds forth on Kant's 'unsociable sociability of men'. In this Provençal hinterland, harsher and more secretive than that around Aix or Avignon, people seek their fellow man while simultaneously fleeing him to be on their own, to get their fill of silence and contemplation, to fabricate a new concept of time, to understand things that normally dance just beyond their grasp.

Those of you who want to discover the real Luberon in all its mystery must forget the statistics and real-estate furore, close all your books and get out there to wander 'with all [your] senses', as the writer Jean Giono recommended.

For it is only then, far from the beaches, creeks, calanques and swimming pools that litter the coastline, that your nostrils will be filled with the heady mix of scents emanating from a land clad in garrigue, vineyards, white and green oak groves, lavender bushes, sea buckthorn berries, junipers... Your eyes will be struck by the intensity of the sun's dazzling glare, the honey-coloured hues of the stone, the hypnotic stillness of the wind-battered mountains, the pride with which the medieval castles stand up to the onslaught of time despite their tattered clothing, the yellows, oranges, reds and mauves of the ochre quarries... Your ears will ring with the obsessive call of the cicadas, the chant of the mistral, the bells of the herds moving up to their mountain pastures, the sighing of the centuries-old olive trees, the raucous din of the marketplace... Your tastebuds will be titillated by an array of flavours—dried hams, Lauris asparagus, Cavaillon melons, roast lamb, goats' cheeses, rosemary-flavoured honey and mellow wines of all hues...

Some people, upset by what they see as degradation, will tell you that the Luberon is victim to tourism and that it has changed irreparably, that it is losing its traditions, its magic, its innocence. But people have been saying that forever, and yet the wonder of the Luberon still persists—and it rarely lets you down.

IL EST INTERDIT DE DEPLACER LES PIERRES

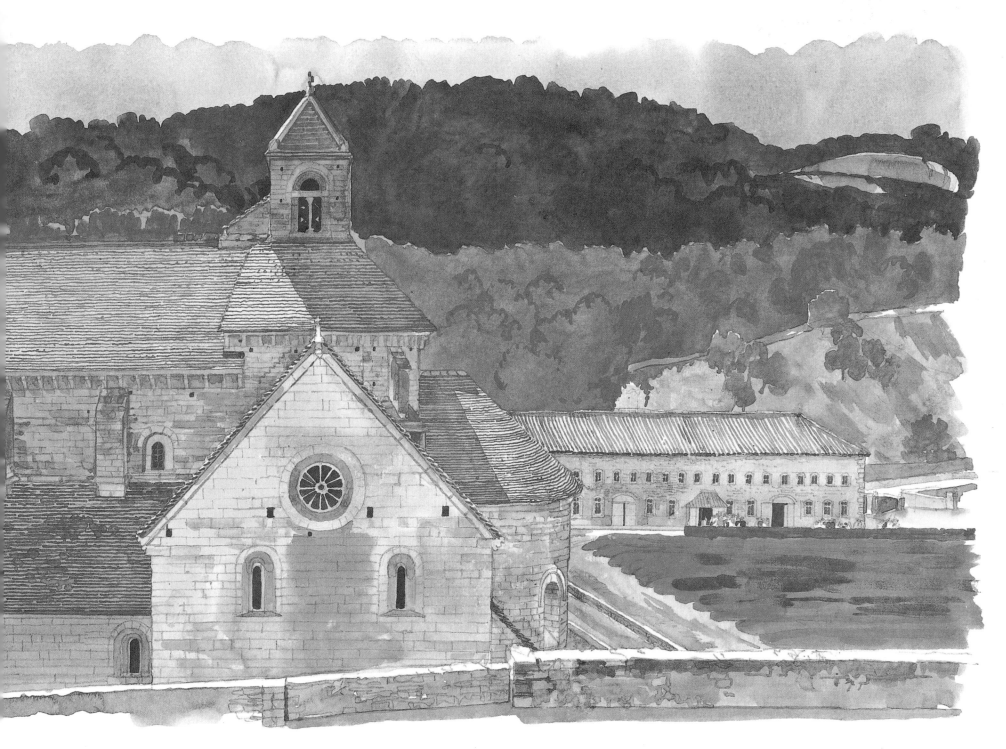

The splendid Cistercian Abbaye de Notre-Dame de Sénanque, founded in 1148 and still inhabited by a community of monks.

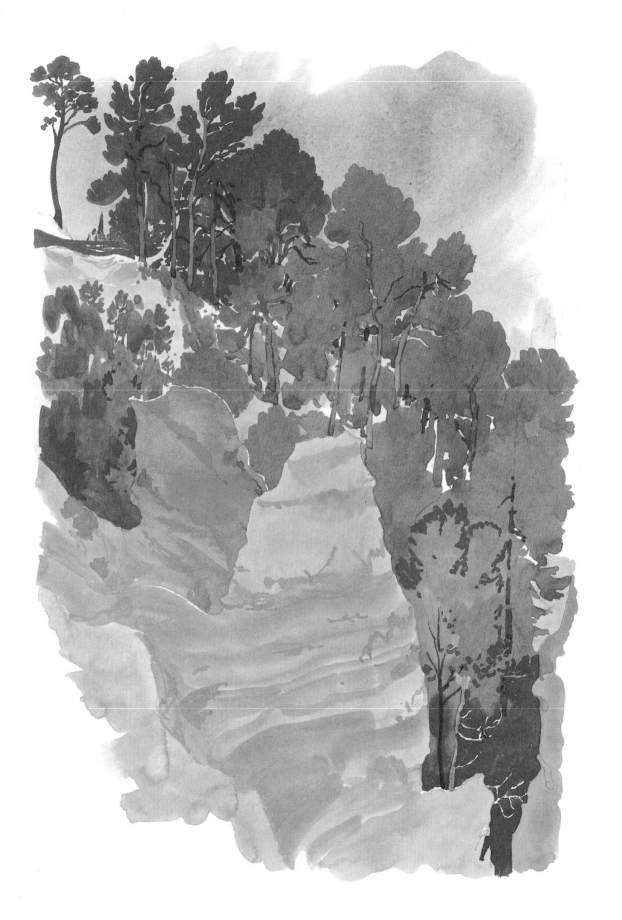

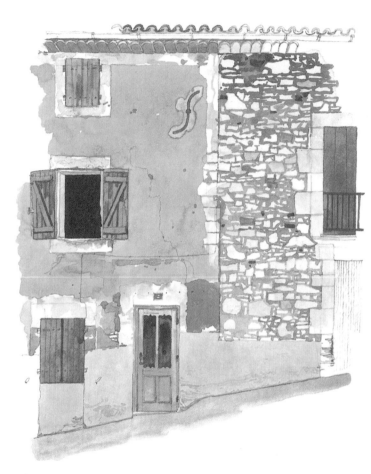

'Delphi the Red' is how actor-cum-
director Jean Vilar poetically
referred to Roussillon, a region
strong on contrast, from the rich
sandy ochres of the area's
quarries to the emerald greens
of its pine-trees...

The enigmatic Village des Bories outside
Gordes. Twenty of these ancient dry-stone
domed buildings have been restored and
now house a collection of traditional tools.
This kind of limestone-slab cabin has
existed in the Mediterranean since
Neolithic times.

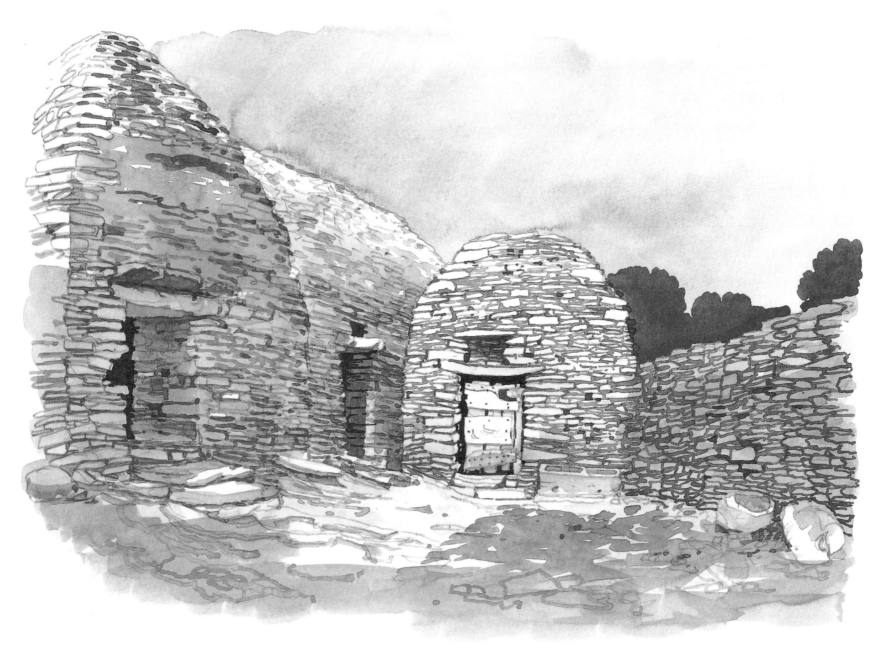

Ménerbes is one of those Provençal perched
villages which takes your breath away;
it did just that to both Nicolas de Staël and Picasso.
'The creator of 30,000 works of art' went as far as buying a
house there as a parting gift for his muse Dora Maar.

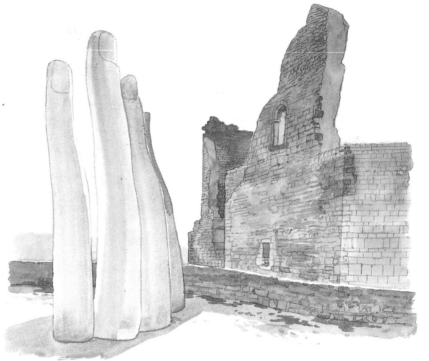

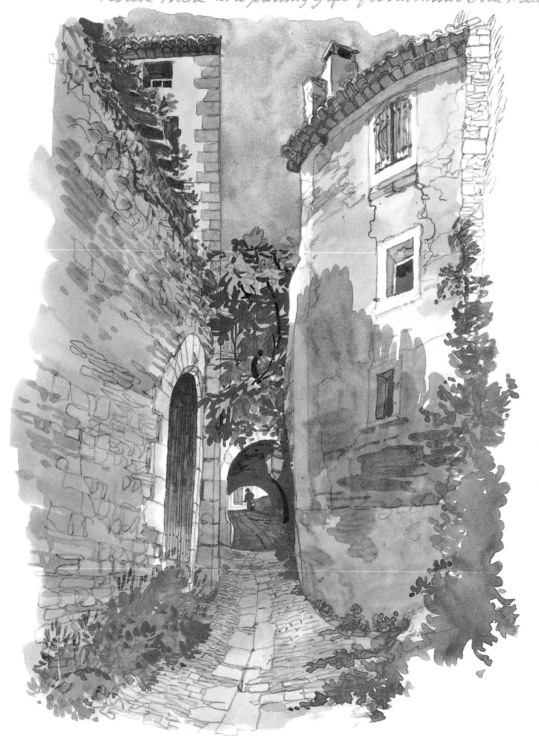

The ruins of the Château de Lacoste,
purchased by couturier-cum-art-patron
Pierre Cardin a few years' ago in order
to save it from total destruction.
It was here that the Marquis de Sade,
Provence's Bluebeard, pursued his
debauches, adding a
theatre to the castle's
glories before fleeing
in the face of the
Revolution. Perhaps
the sun-dial remembers
something of all this.

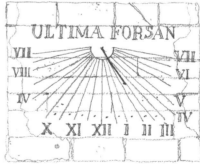

ULTIMA FORSAN

VII VII
VIII VI
IV V
X XI XII I II III

Deserted by its inhabitants at the
beginning of the 20th Century,
Oppède-le-Vieux subsequently
found favour with a handful
of artists who, seduced by its
rugged charm, set
about
restoring it.

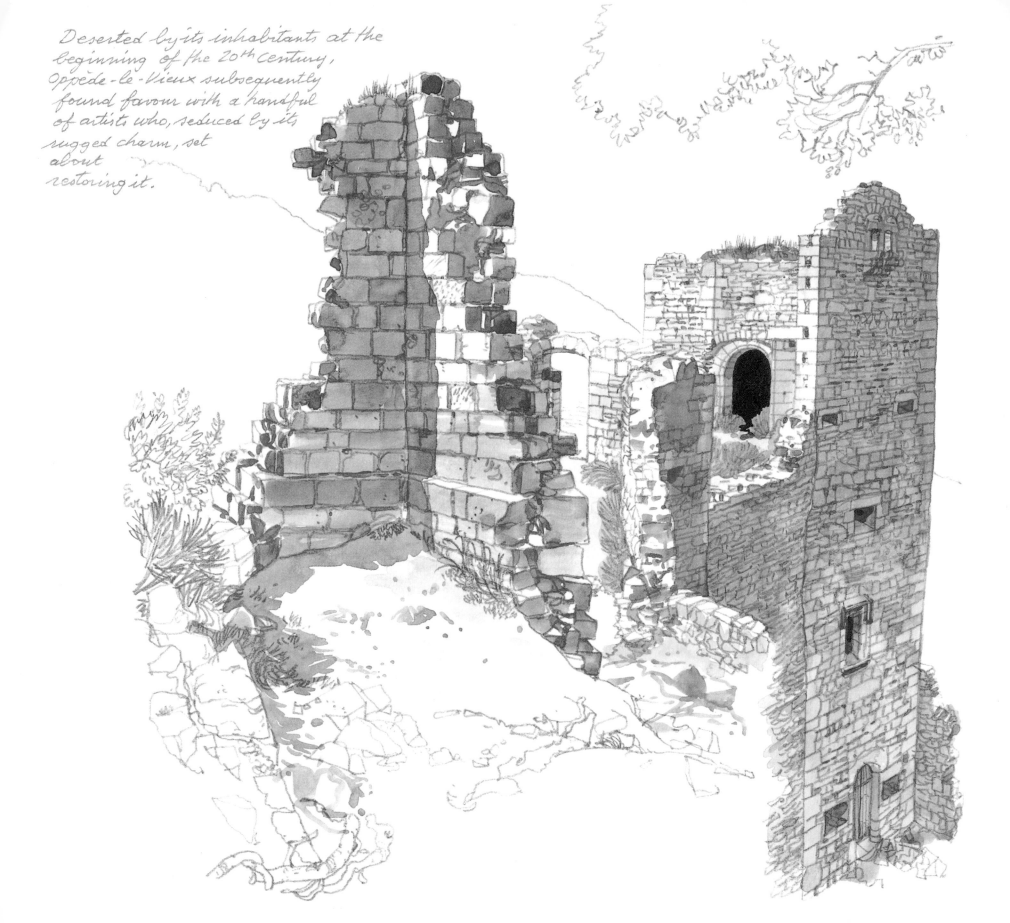

Where the Petit Luberon and the
Grand Luberon meet lies Bonnieux,
bathed in the setting sun of
warm July evenings. If you climb the 96
stone steps up to its church, you can look
over the vineyards of the Calavon
valley and the hillsides covered
with Aleppo pines.

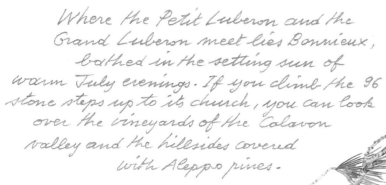

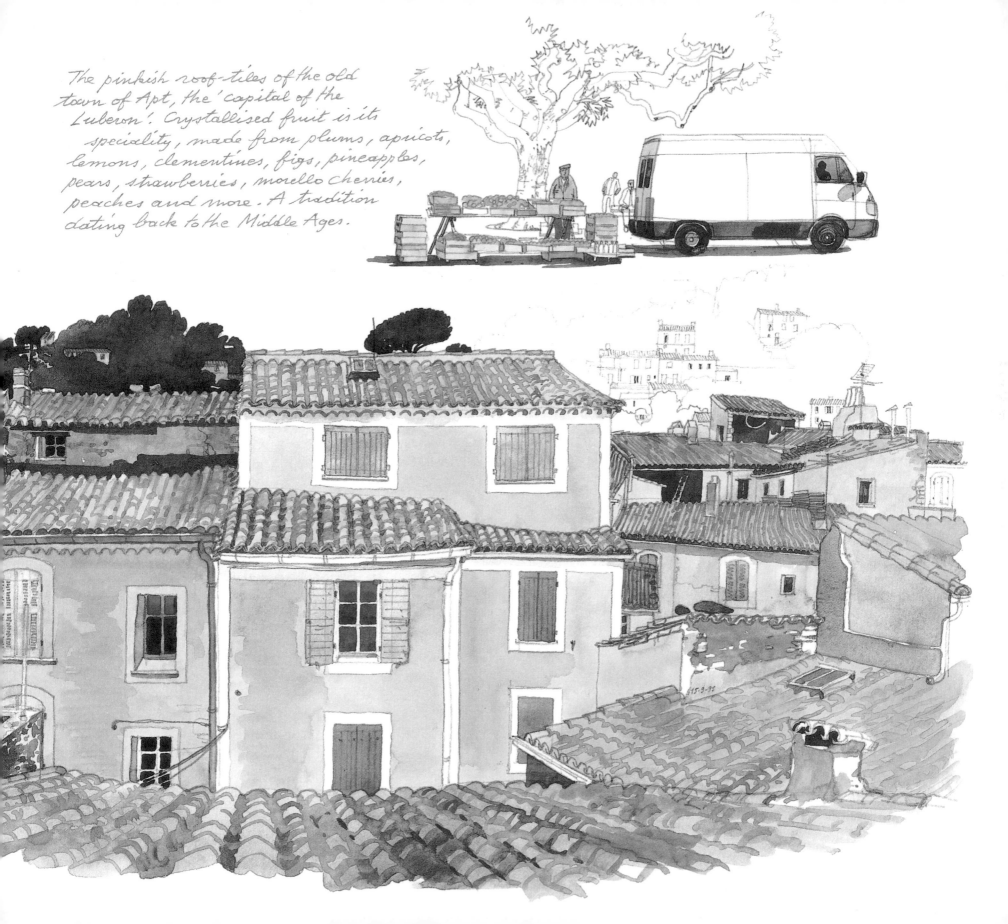

The pinkish roof-tiles of the old
town of Apt, the 'capital of the
Luberon'. Crystallised fruit is its
speciality, made from plums, apricots,
lemons, clementines, figs, pineapples,
pears, strawberries, morello cherries,
peaches and more. A tradition
dating back to the Middle Ages.

The Château d'Ansouis, in the south of
the Vaucluse, celebrated its millennium in 1960.
In its magnificent French gardens there's an abundance
of box-hedge mazes and 18th-century fountains and ornamental ponds
(one of which is 42 m long and 2 m deep) topped with a majestic cypress alley, with
the most splendid view over the Luberon. Overgrown with ivy and brambles before
being rescued by the Duc and Duchesse de Sabran-Pontevès, the château and
its park were sold to an Aixois couple for 5.6 m euros in January 2008.

The Château de Lourmarin, Provence's most important Renaissance château. The writer Albert Camus was captivated by the light and colours of this village in the Petit Luberon which reminded him of the Algeria of his childhood. In 1958, the year he won the Nobel Prize for Literature, Camus purchased an old silk farm here. He is buried in the local cemetery, in a very simple tomb surrounded by laurel-trees and rosemary bushes.

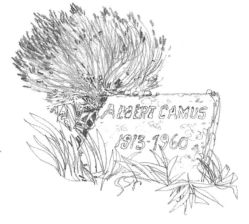

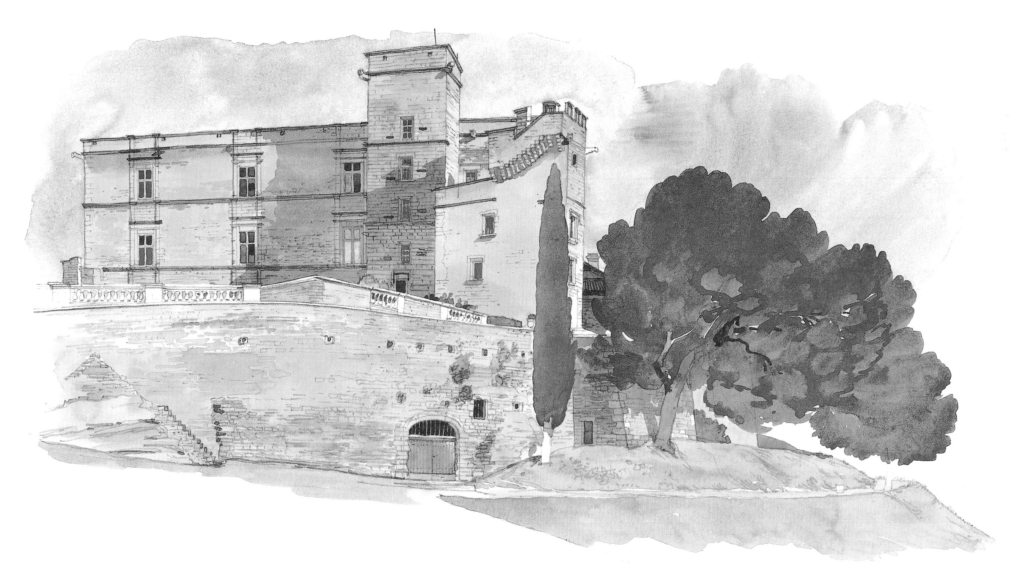

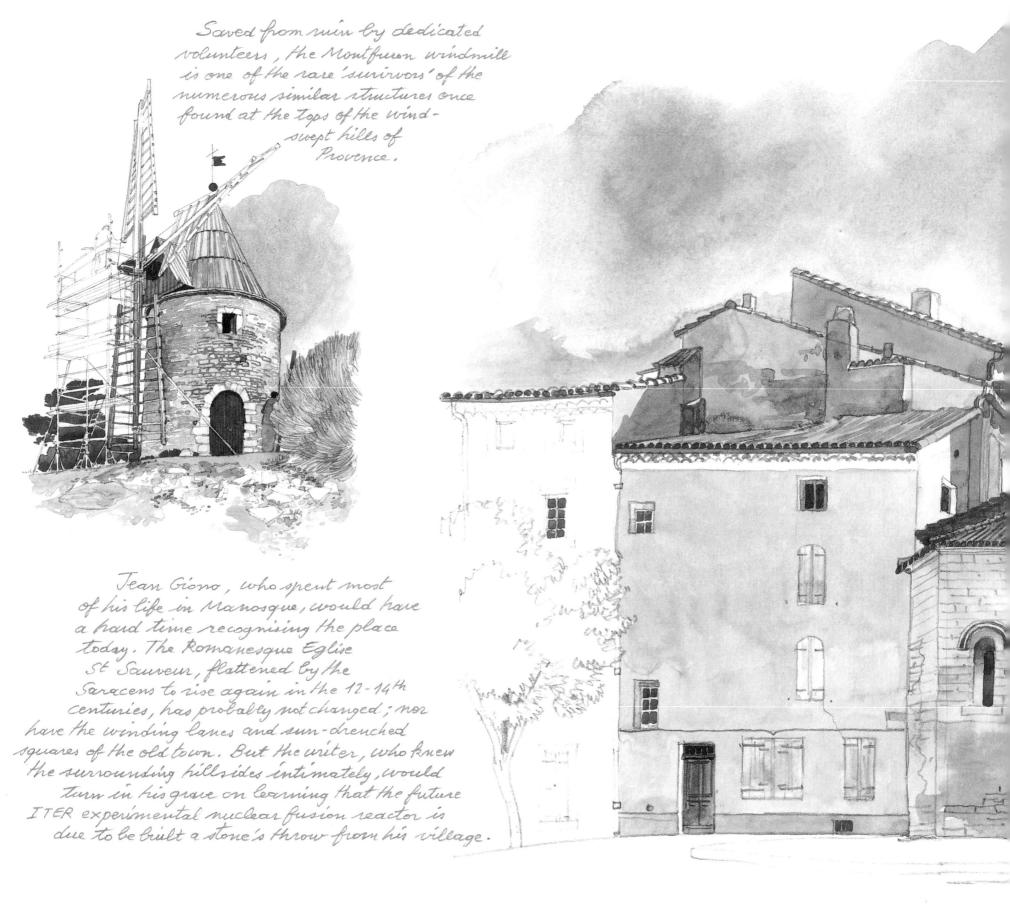

Saved from ruin by dedicated
volunteers, the Montfuron windmill
is one of the rare 'survivors' of the
numerous similar structures once
found at the tops of the wind-
swept hills of
Provence.

Jean Giono, who spent most
of his life in Manosque, would have
a hard time recognising the place
today. The Romanesque Eglise
St Sauveur, flattened by the
Saracens to rise again in the 12-14th
centuries, has probably not changed; nor
have the winding lanes and sun-drenched
squares of the old town. But the writer, who knew
the surrounding hillsides intimately, would
turn in his grave on learning that the future
ITER experimental nuclear fusion reactor is
due to be built a stone's throw from his village.

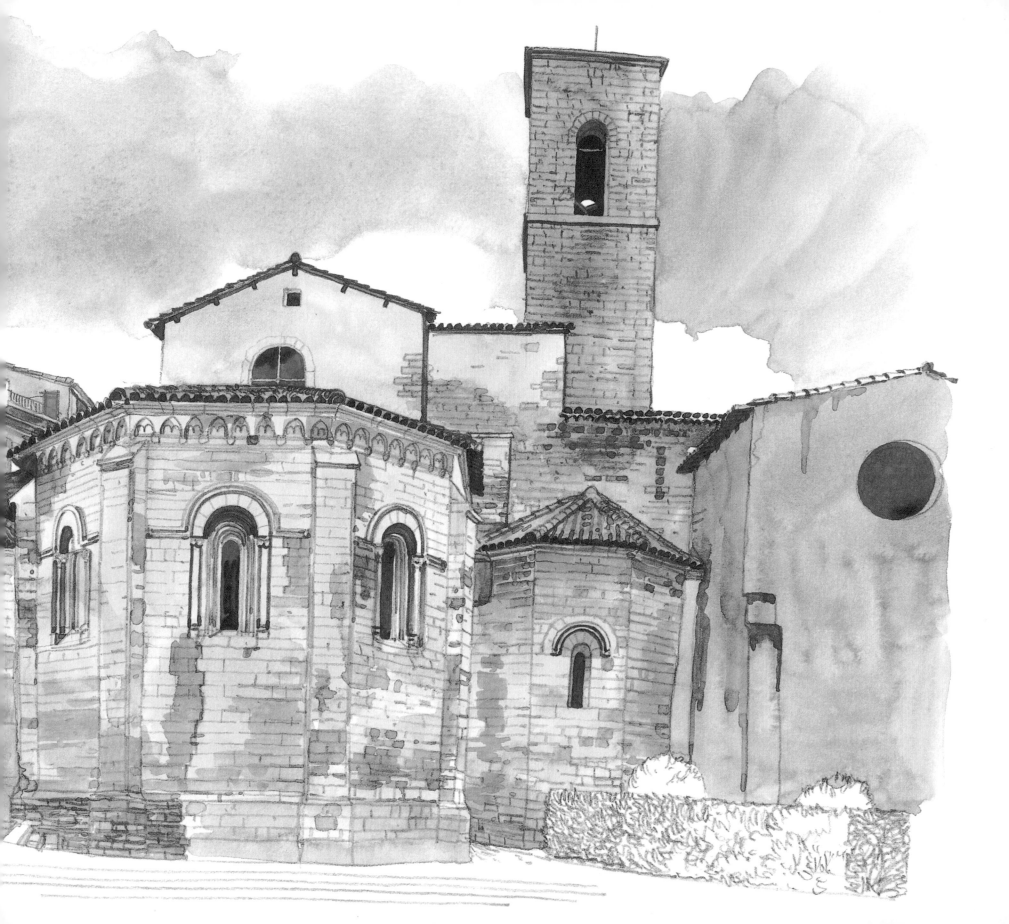

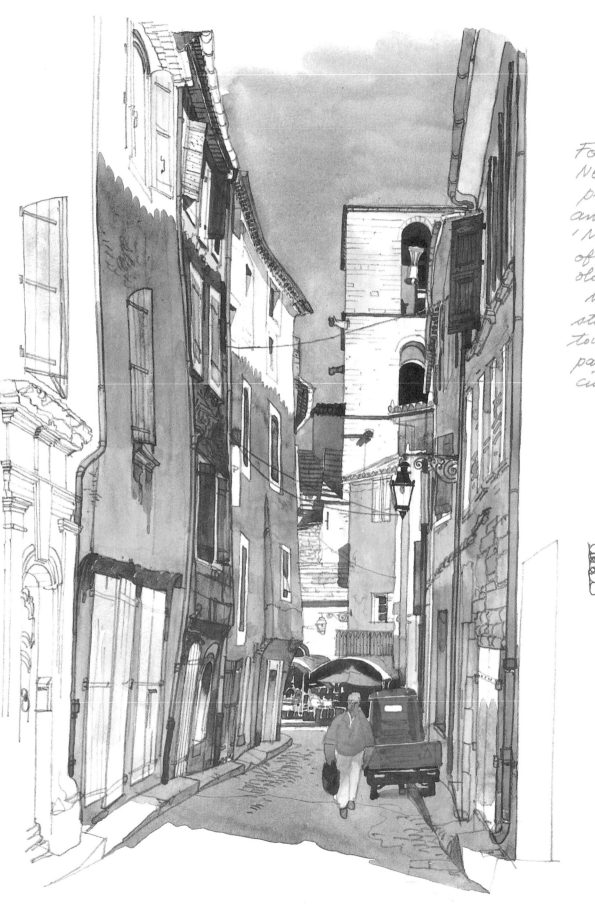

Forcalquier's cathedral, Notre-Dame de Bourguet, is the proud possessor of a bell answering to the gentle name 'Maria Sauvaterra', as well as of an organ nearly 400 years old. In the lee of Lure Mountain, Forcalquier itself still resembles a medieval town – the 'calade' (a steep, paved street) leading to the citadel is a fine example of its kind.

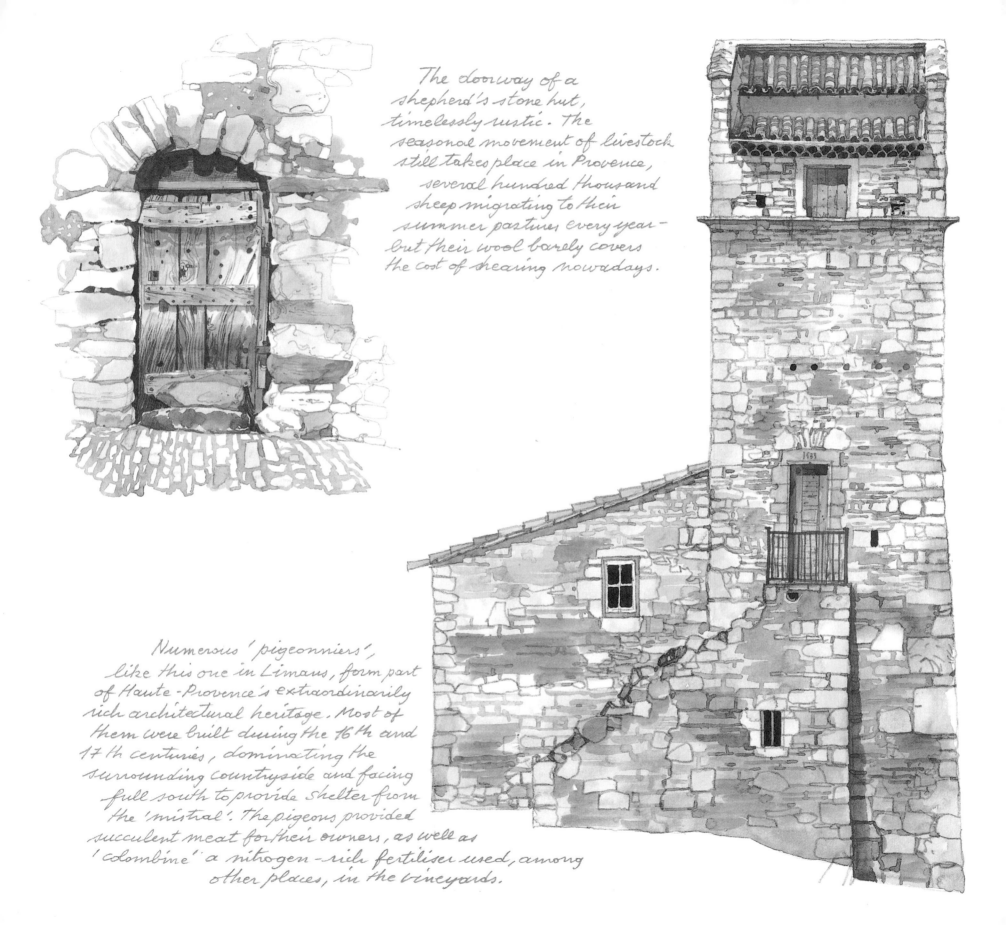

The doorway of a shepherd's stone hut, timelessly rustic. The seasonal movement of livestock still takes place in Provence, several hundred thousand sheep migrating to their summer pastures every year – but their wool barely covers the cost of shearing nowadays.

Numerous 'pigeonniers', like this one in Limans, form part of Haute-Provence's extraordinarily rich architectural heritage. Most of them were built during the 16th and 17th centuries, dominating the surrounding countryside and facing full south to provide shelter from the 'mistral'. The pigeons provided succulent meat for their owners, as well as 'colombine', a nitrogen-rich fertiliser used, among other places, in the vineyards.

Aix and the Pays Salonnais

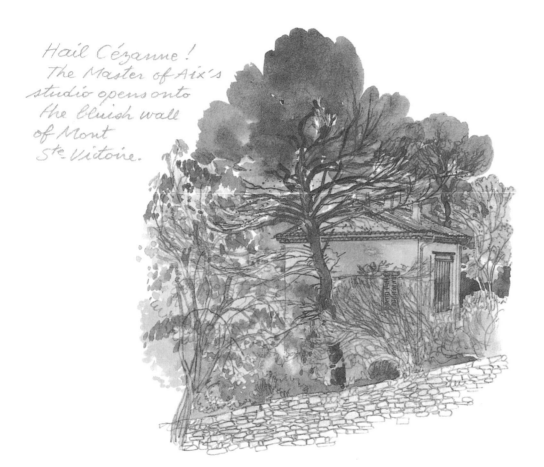

Hail Cézanne! The Master of Aix's studio opens onto the bluish wall of Mont Ste-Victoire.

from the Bibémus quarries, Aquae Sextiae, as it used to be known in Roman times, could almost be referred to nowadays as the 21st arrondissement of the French capital, so popular has it become with rich Parisians seeking an alternative base.

To the east of the city lies Mont Ste-Victoire, referred to locally as 'la Sainte', immortalised on 87 different occasions by Paul Cézanne, a local lad deeply attached to his roots. From his studio among the olive trees on the Colline des Lauves, the Master had a perfect view of his model. 'Look at this Sainte-Victoire,' he cried, captivated by the mass of rock 1 km tall and 8 km wide. 'What force, what a thirst for sunshine, and what melancholy, towards evening, when all this weight falls away! These blocks were made from fire, and they still have fire in them. In the day, the shade appears to back away shuddering, to be afraid of them. When large clouds pass overhead, their shadows quiver on the rocks, as if burnt, immediately swallowed up by a mouth of fire.'

Tear yourself away from the austere beauty of this monolith and go down to the banks of the Durance for the Abbaye de Silvacane, one of Provence's three Cistercian wonders. Keep going through the Pays Salonnais until you reach Salon-de- Provence where Nostradamus spent the last 20 years of his life. There you'll find the Chateau de l'Emperi, the oldest fortress in Provence. Finally, you'll come to the Etang de Berre, once full of fish but now largely ruined by the petrochemical industry. You can see that life in Provence is not always a vast, tranquil lake…

Aix represents Provence's bourgeois side, with grand boulevards like the Cours Mirabeau lined by wide pavements and centuries-old plane trees, elegant 17th-century town houses with balconies borne by atlantes and caryatids, pretty little squares bedecked in flowers, narrow twisting lanes and fountains providing welcome refreshment in the heat of the day. Built in yellowish ochre stone

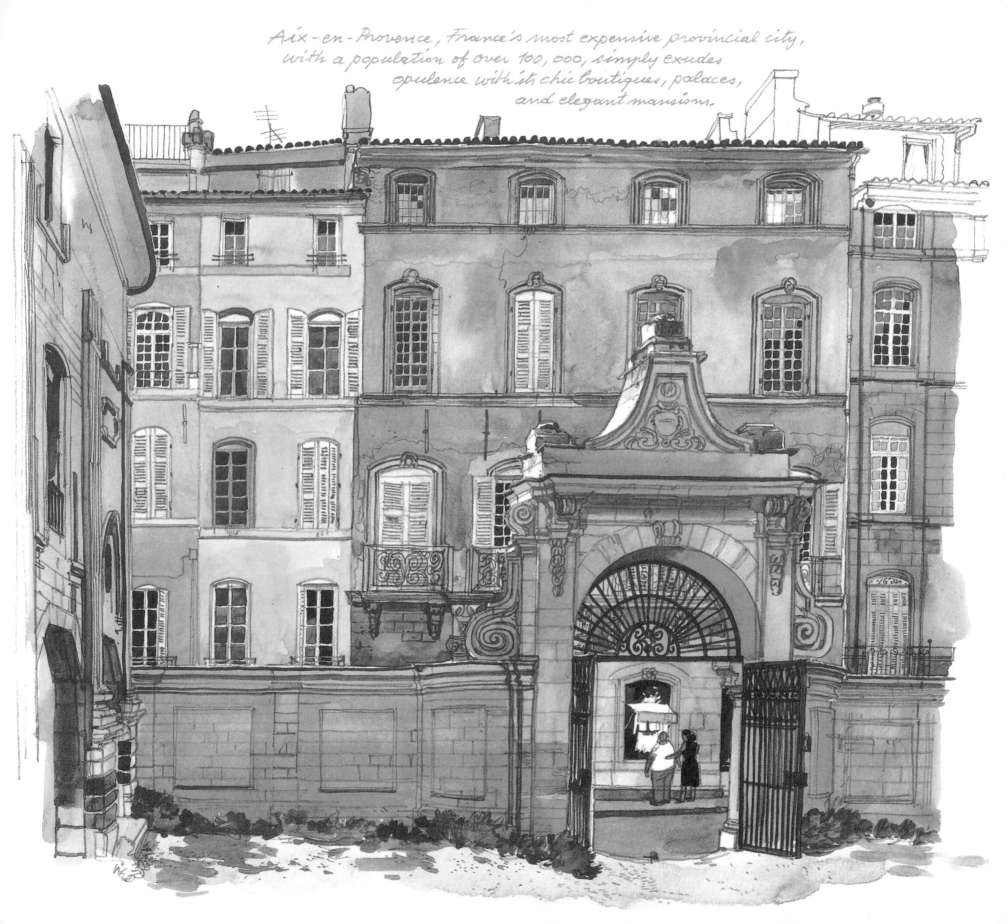

Aix-en-Provence, France's most expensive provincial city,
with a population of over 100,000, simply exudes
opulence with its chic boutiques, palaces,
and elegant mansions.

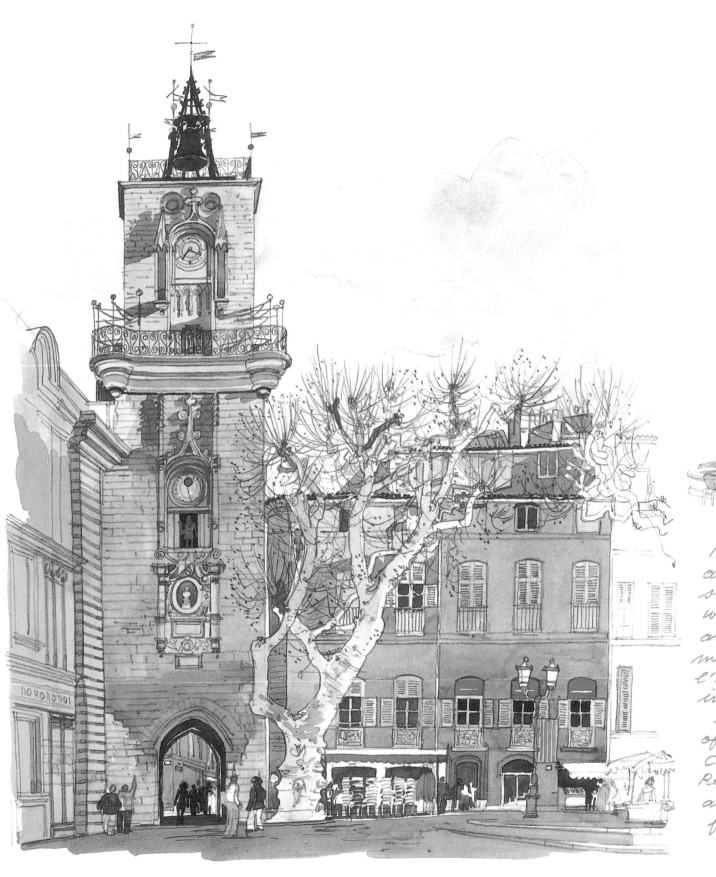
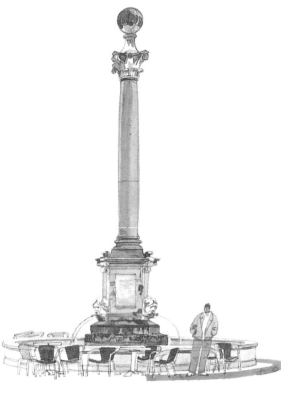

Nothing beats wandering around the old town of Aix, sampling the brilliantly white almond 'Calissons', and devouring architectural marvels such as the Tour de l'Horloge with its wrought-iron belfry, built in 1510.

In the square in front of the Italianate town hall, Chastel's fountain has a Roman column in its midst and gargoyles spewing forth water from the Pinchinats.

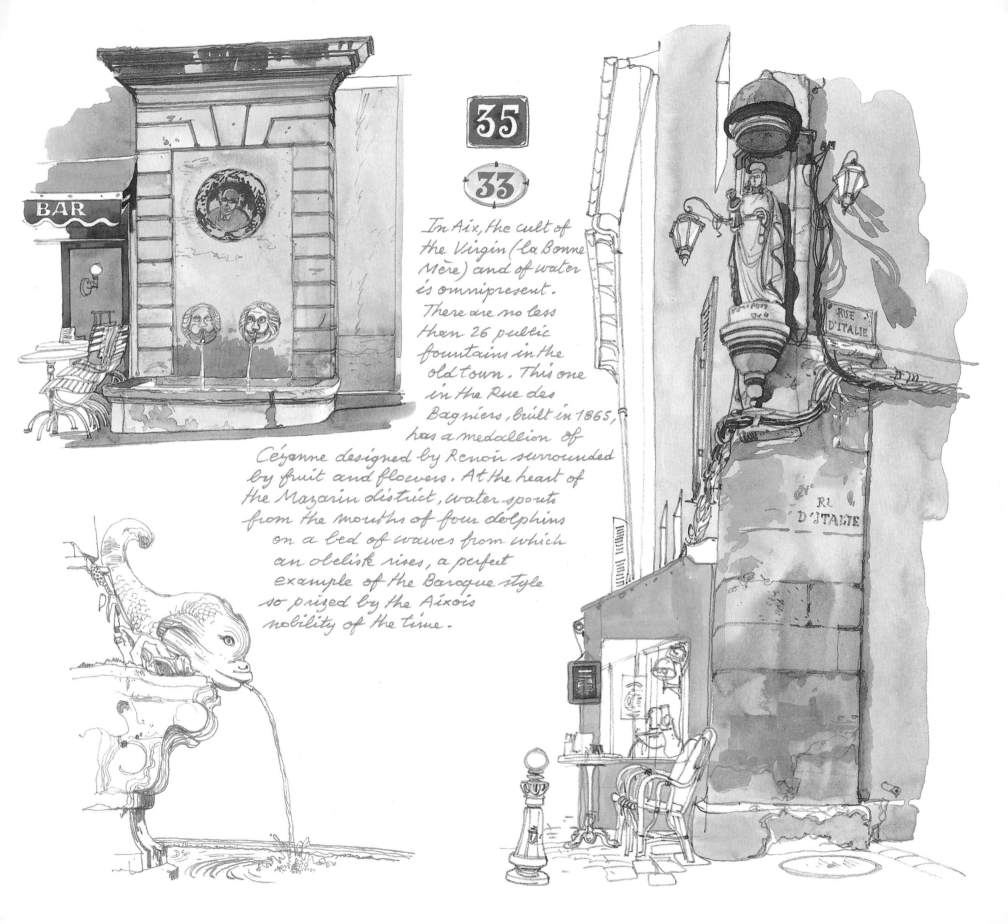

BAR

35

33

In Aix, the cult of the Virgin (la Bonne Mère) and of water is omnipresent. There are no less than 26 public fountains in the old town. This one in the Rue des Bagniers, built in 1865, has a medallion of Cézanne designed by Renoir surrounded by fruit and flowers. At the heart of the Mazarin district, water spouts from the mouths of four dolphins on a bed of waves from which an obelisk rises, a perfect example of the Baroque style so prized by the Aixois nobility of the time.

RUE D'ITALIE

RUE D'ITALIE

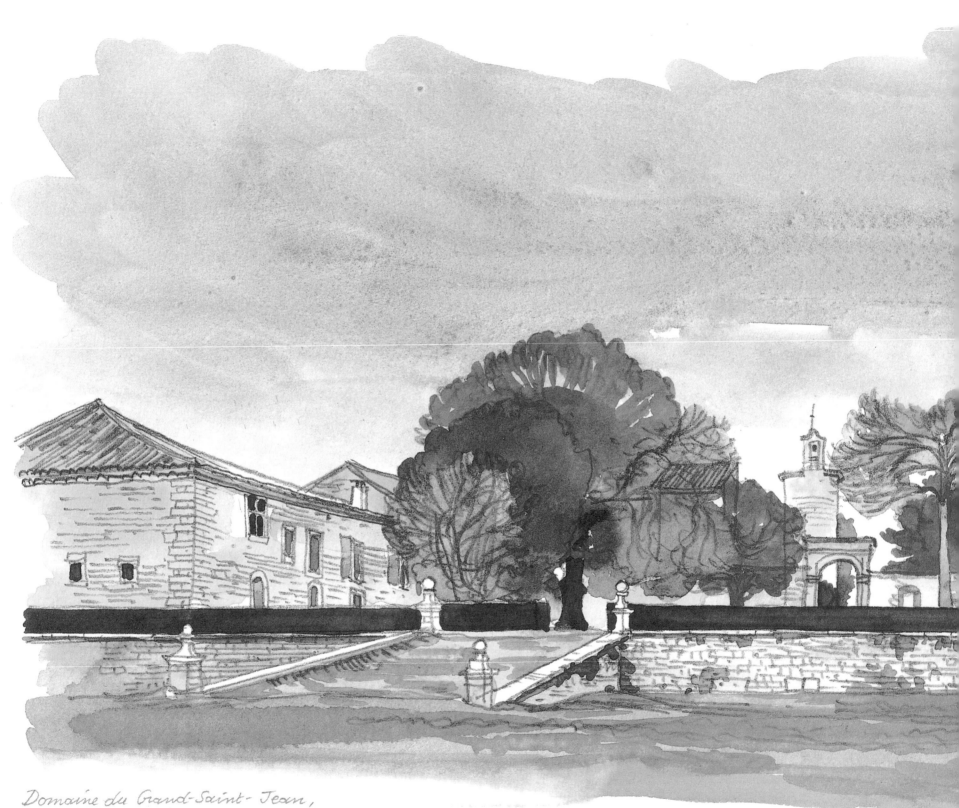

Domaine du Grand-Saint-Jean,
a 240-hectare site at the foot of the Trévaresse mountain chain, is a reminder
of Aix's rich past, with an 11th-century Romanesque chapel dedicated to John the Baptist, an elegant
Renaissance château, and outbuildings including a 'bergerie', woodlands, gardens and more.

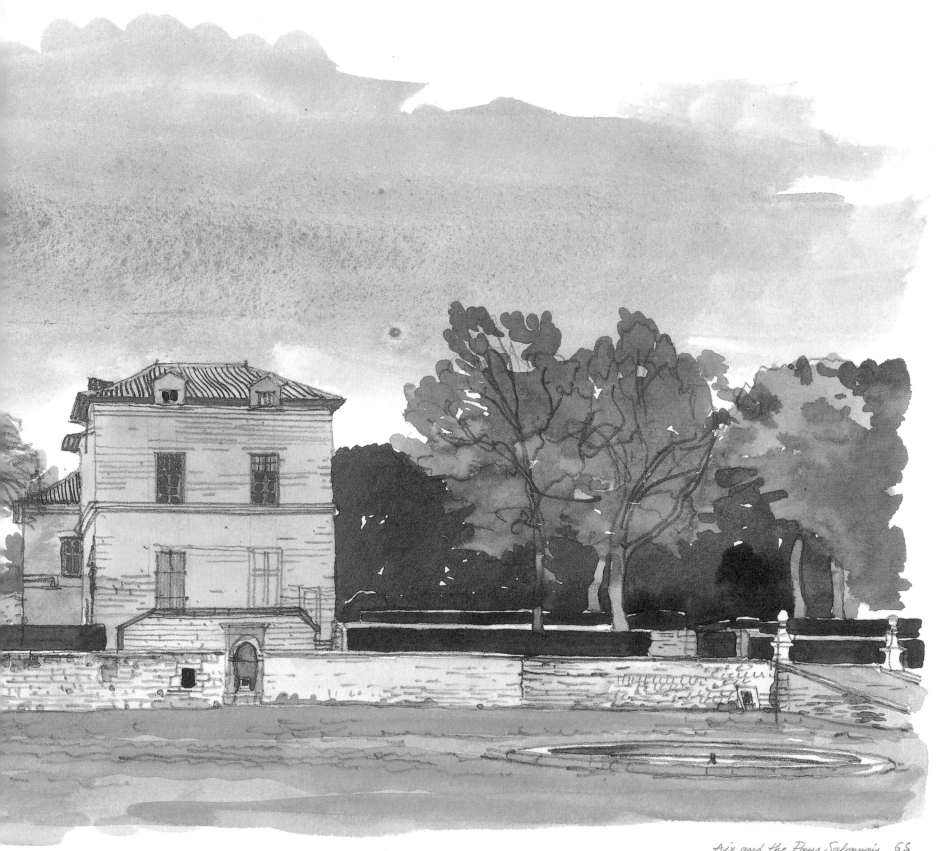

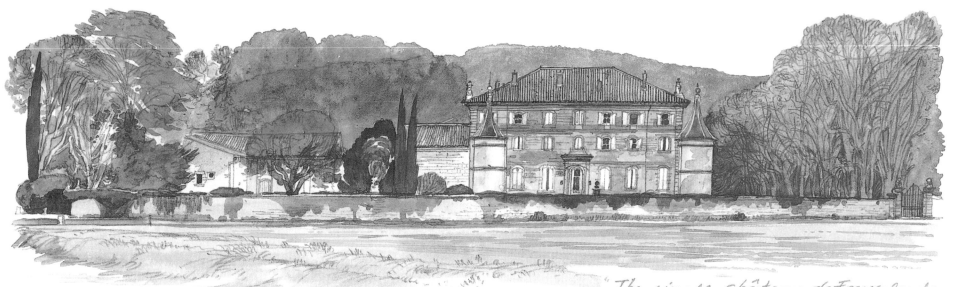

" The sizeable Château de Fonscolombe,
built in the 18th century by a family of Aixois parliamentarians,
and another more modest 'bastide' overlooking the waters of the Touloube on a breezy November day.

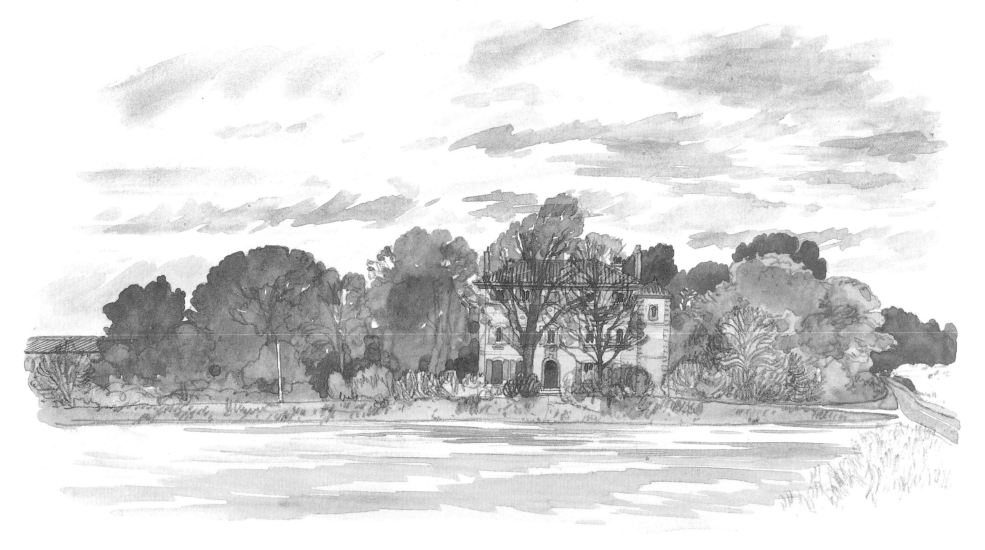

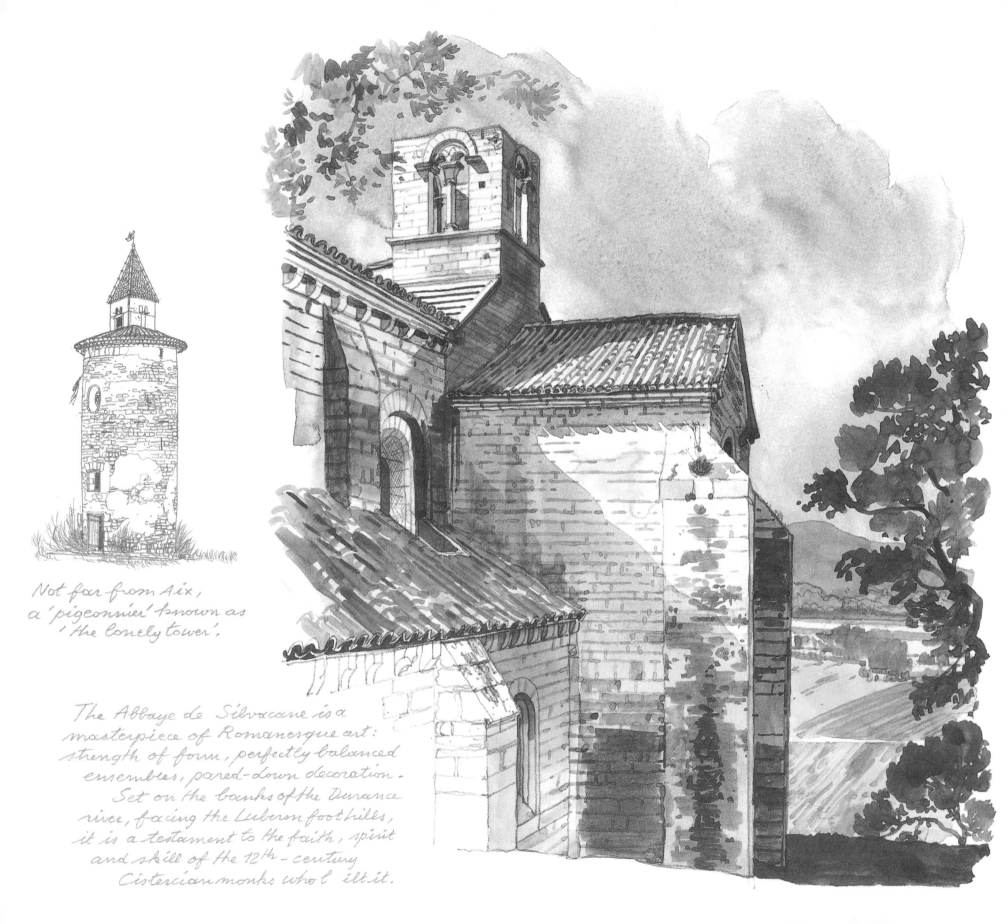

Not far from Aix,
a 'pigeonnier' known as
'the lonely tower'.

The Abbaye de Silvacane is a
masterpiece of Romanesque art:
strength of form, perfectly balanced
ensembles, pared-down decoration.
 Set on the banks of the Durance
river, facing the Luberon foothills,
it is a testament to the faith, spirit
and skill of the 12th-century
Cistercian monks who built it.

Step back in time as you walk
through vaulted passageways in Trets,
which lies between the Monts Auréliens
and the mythical Mont Ste-Victoire;
and then look up to discover the
unfinished belfry of the Église
Notre-Dame de Nazareth.

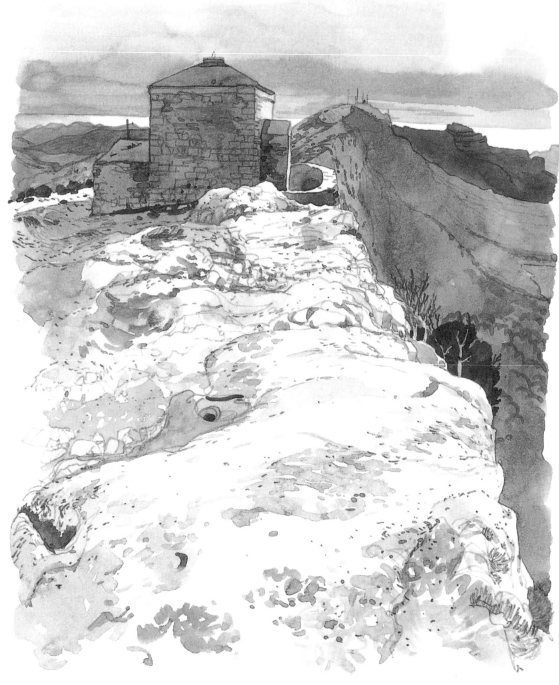

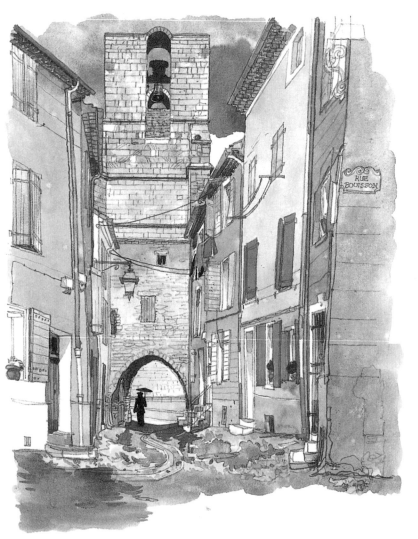

A small chapel stands aloft the St-Pilon
pass in the Ste-Baume mountains where,
according to tradition, Mary Magdalene is said
to have spent her last years.
Beech forests line the northern face of
the massif far below, forming a dense ecological
reserve. The whole place has a strangely
mystical feel to it.

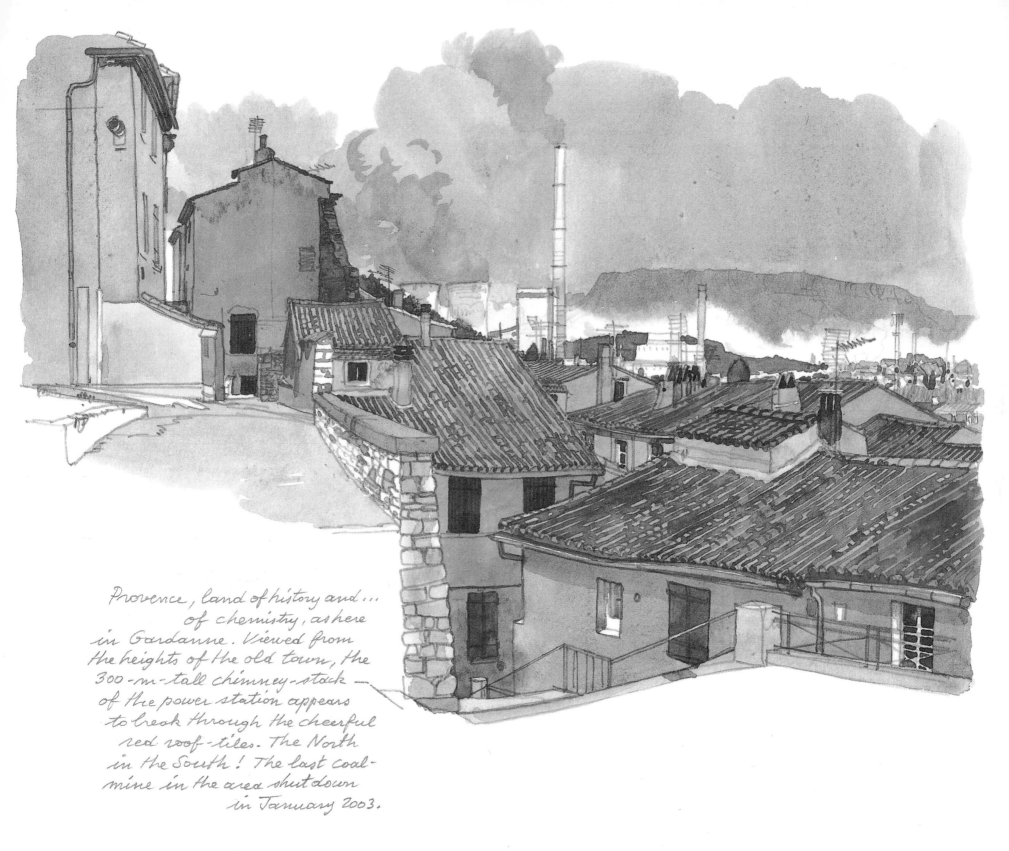

Provence, land of history and ...
of chemistry, as here
in Gardanne. Viewed from
the heights of the old town, the
300-m-tall chimney-stack —
of the power station appears
to break through the cheerful
red roof-tiles. The North
in the South! The last coal-
mine in the area shut down
in January 2003.

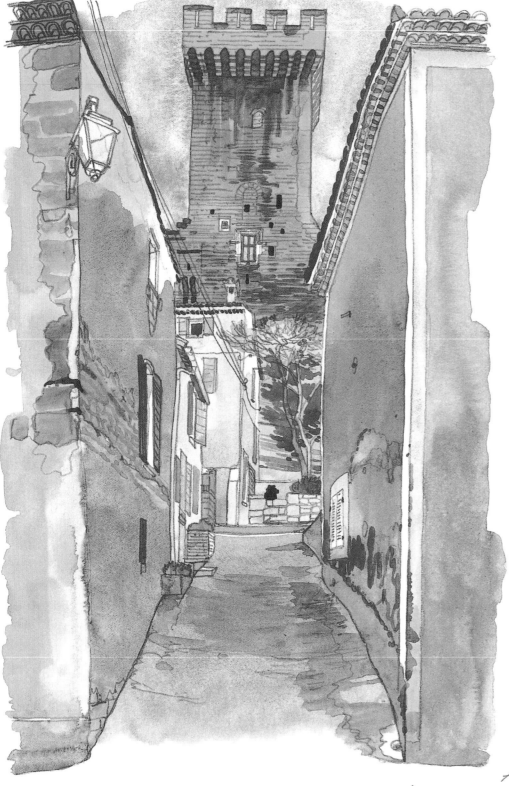

The moss-covered fountain
in Place Croustillat in Salon-de-
Provence resembles a vast green
mushroom made up of layers of limestone
acaretions which hide the two
original 18th-century
basins.

The Château de l'Empéri looks
down imposingly on Salon-de-Provence
from up high on the Rocher du Puech,
the vanguard of the neighbouring
Alpilles mountains. It is Provence's most
ancient fortress and one of the region's three largest (together with
the Palais des Papes in Avignon and the
Château des Ducs d'Anjou in Tarascon).

The fishing-port of St-Chamas, on the edge of the Étang de Berre
with ancient troglodytic dwellings on the skyline above.

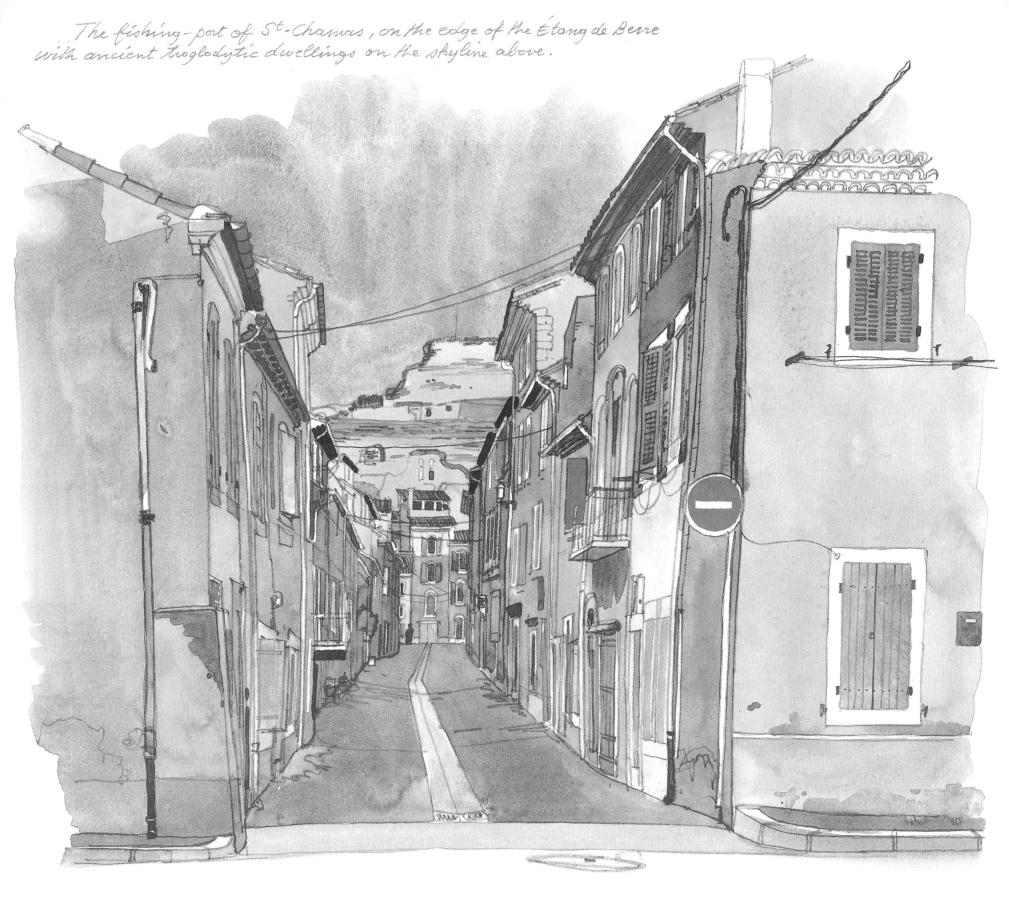

Arles, Camargue and the Crau

Despite the fact that Arles has repeatedly been besieged and even pillaged by the Visigoths, the Franks, the Ostrogoths and other Saracens, and that the glorious remains lining its streets give a less than complete picture of its splendid past in Antiquity, the city is still an extraordinarily powerful time machine. Situated at the estuary of France's most turbulent river, the city of a hundred Roman and Romanesque wonders has faced its destiny over the centuries on some occasions with the stolidness of a true Camargue horse munching on a gorse bush under a heavy grey sky, and on others with all the fury of a bull let loose for an abrivado. The days of Van Gogh and his friend Gauguin coming to stay are gone forever, but that has not prevented the nation's most spread-out commune (53 km to the sea in the south and 24 km from east to west)—a place frequently hit by the most terrible floods, awash with debts and somewhat lost in the modern world—from remaining true to itself and developing a love of traditional festivals and a sense of culture, whatever the cost.

Arles and the Camargue are intimately linked. This vast alluvial plain, 150,000 hectares in size, clasped between the arms of the Rhône, even more captivating under the winter sun than in the glaring heat of the summer, remains an untamed place of lakes, salt-plains, prairies, reed beds and paddy fields inhabited

*Reeds swaying in the November breeze
like so many horses' names ... for this is the Camargue,
wedged between the branches of the Rhône.*

by pink flamingos, purple herons, coots, egrets, teals—and mosquitoes. Not forgetting His Majesty *lou biou* (the bull), the focus of all real passion. You have to have come literally face to face with one of these obsidian beasts in order to comprehend the religious deference which they are accorded here in the Camargue, this place of legend and harmony located somewhere between the water and the sky.

The Arles landscape also includes the Plaine de la Crau, liberally dotted with pebbles deposited by the Durance river during the last ice-age. Here, at the foot of the Alpilles, hides the last steppe in France.

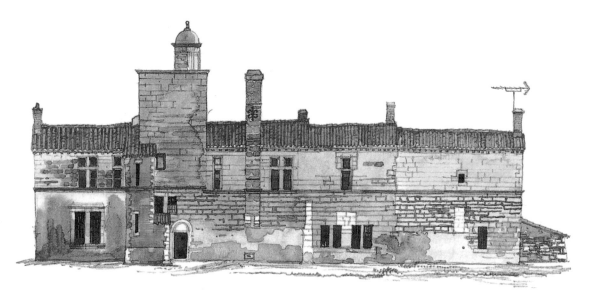

*Within the triangle of sand and water
that makes up the Camargue, an old 'mas'
(farmhouse) blends in perfectly with the
surroundings.*

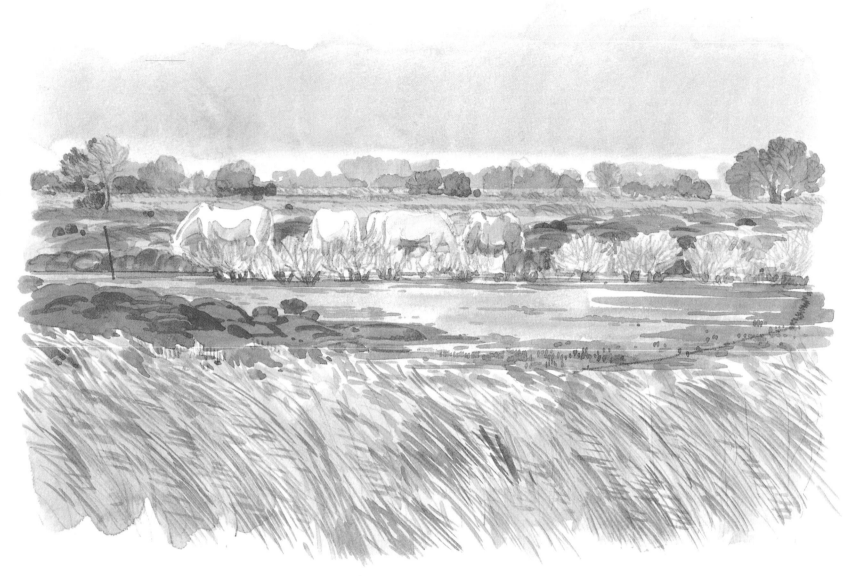

Camargue horses are reared in
the wild, in freely roaming herds.
Grey at birth, they quickly turn
white, and are known for their
remarkable agility. They are all
bred locally. Rice grows right
up to the doors of the 'gardians'
cabins. It is said that the
delta's first rice paddy was
created in 1864 on the
Domaine de Paulet.

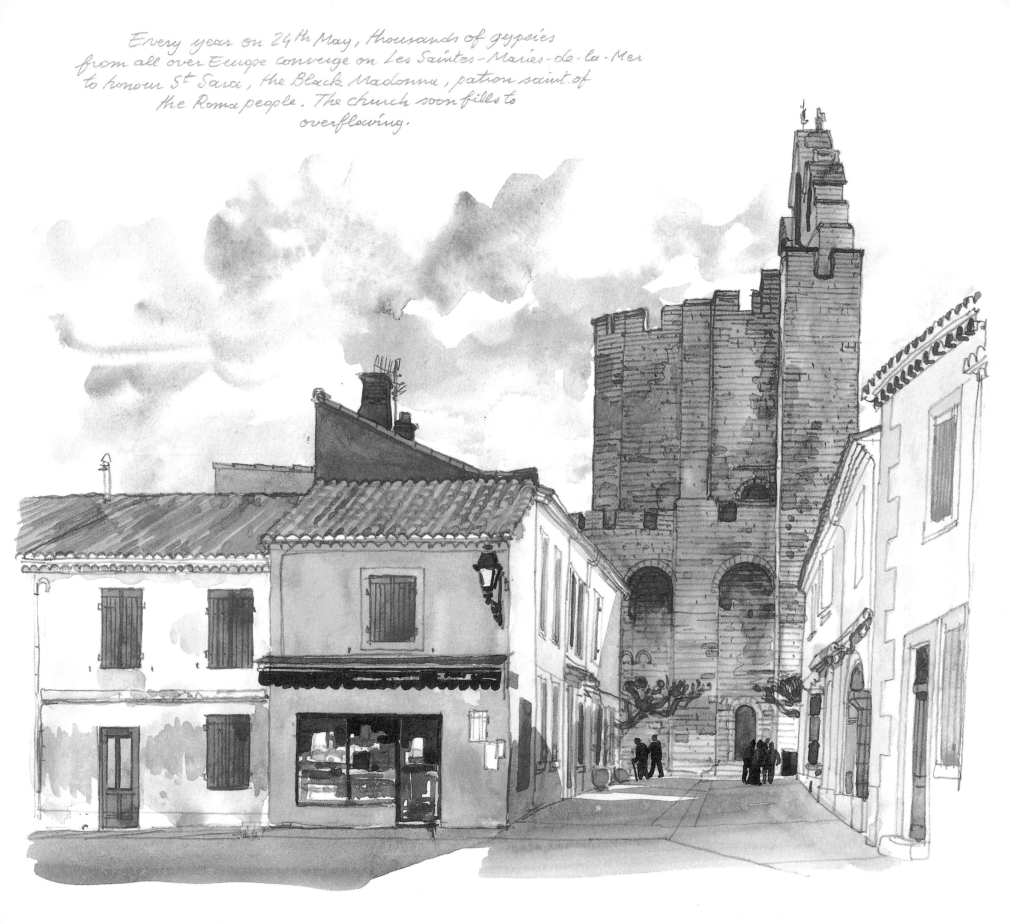

Every year on 24th May, thousands of gypsies
from all over Europe converge on Les Saintes-Maries-de-la-Mer
to honour St Sara, the Black Madonna, patron saint of
the Roma people. The church soon fills to
overflowing.

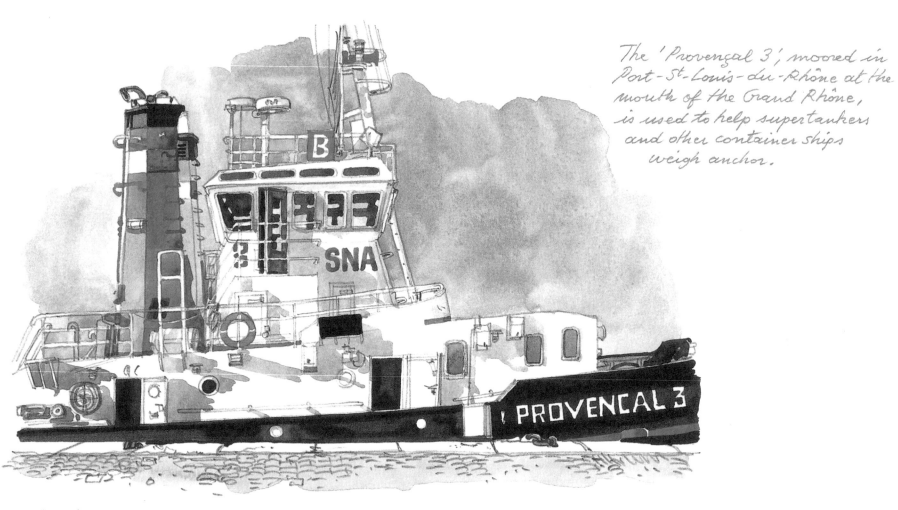

The 'Provençal 3', moored in Port-St-Louis-du-Rhône at the mouth of the Grand Rhône, is used to help supertankers and other container ships weigh anchor.

The Étang de Vaccarès, Camargue's largest lake. With the approach of winter, hordes of migrating birds come here to nest. There are few more spectacular sights than a flock of pink flamingos skimming the shimmering surface of the 'Grand Mar'.

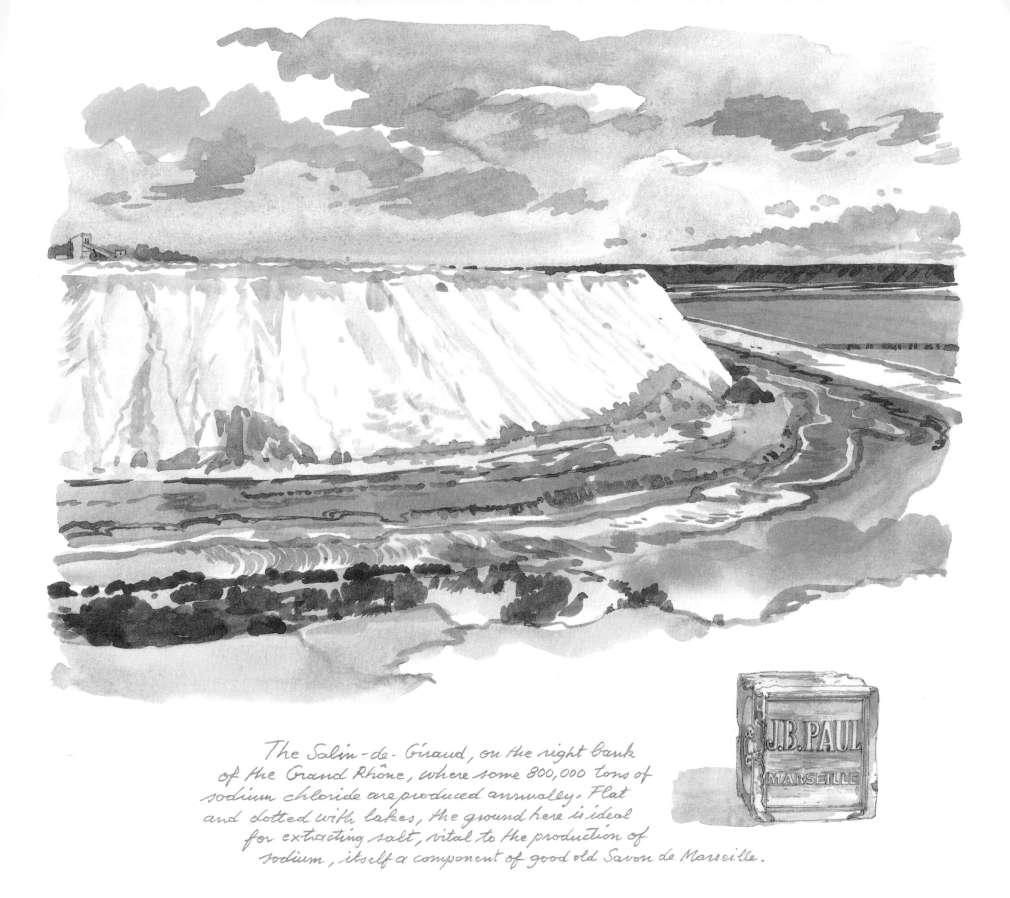

The Salin-de-Giraud, on the right bank of the Grand Rhône, where some 800,000 tons of sodium chloride are produced annually. Flat and dotted with lakes, the ground here is ideal for extracting salt, vital to the production of sodium, itself a component of good old Savon de Marseille.

J.B. PAUL
MARSEILLE

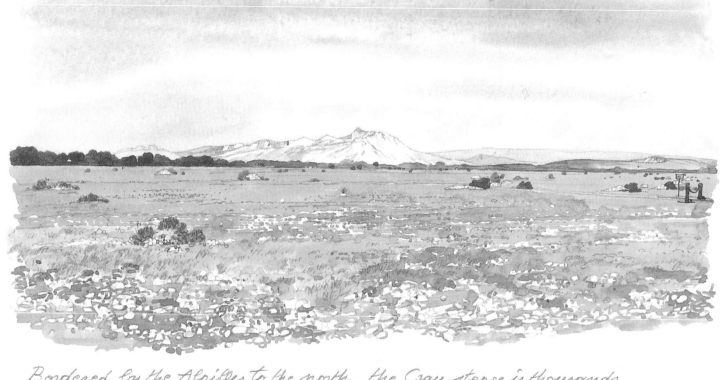

Bordered by the Alpilles to the north, the Crau steppe is thousands
of hectares of vegetation quite unlike that anywhere else in France.
Surrounded by the fertile, marshy 'green Crau', this fossilised
delta of the Durance river, carpeted with pebbles, resembles the fringes
of the Sahara more than typical Provençal landscape.
The Cravenc shepherds have carved onto the stone walls of their huts
lasting reminders of their time spent up on these windswept plains.

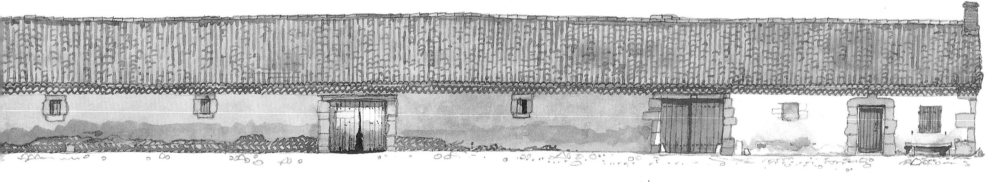

ALESSIO 1882
ARNAUDO 24

MICHAUD ♦ LEON
DE BOUVANTE DRÔME
AGE DE 24 ANS EN 1888

1891

1883 1900

Just north of Arles
lies the Abbaye de
Montmajour, founded in 948
by Benedictine monks. Numerous
nautical images decorate the walls of
this venerable monastery.

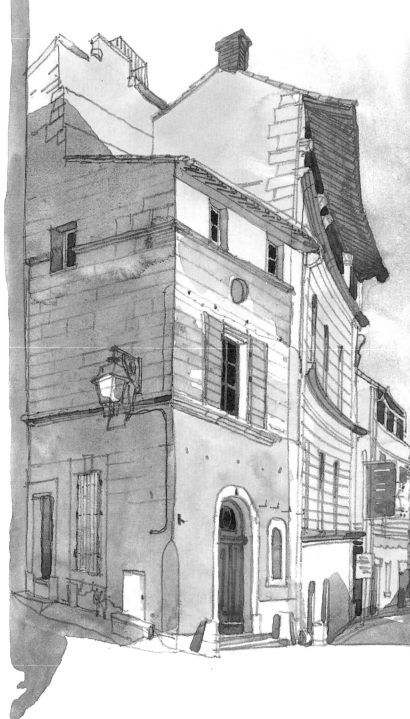

PLACE DU FORUM

RUE DES THERMES

RUE DES ARÈNES

Referred to as 'the little Rome of the Gauls' by the 4th-century poet Ausonius, Arles' Roman past still echoes in its street names.

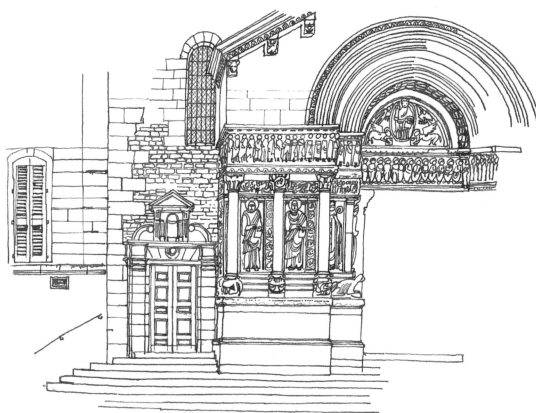

Two jewels among the breathtaking architectural heritage of France's largest commune (759 square km): one Roman, the amphitheatre; and the other Romanesque, the portal of the Eglise St-Trophime. The former, based on the Coliseum in Rome, opens its arms to the Arles feria at the start of the bullfighting season, while on the tympanum of the latter, Christ raises his right hand in blessing.

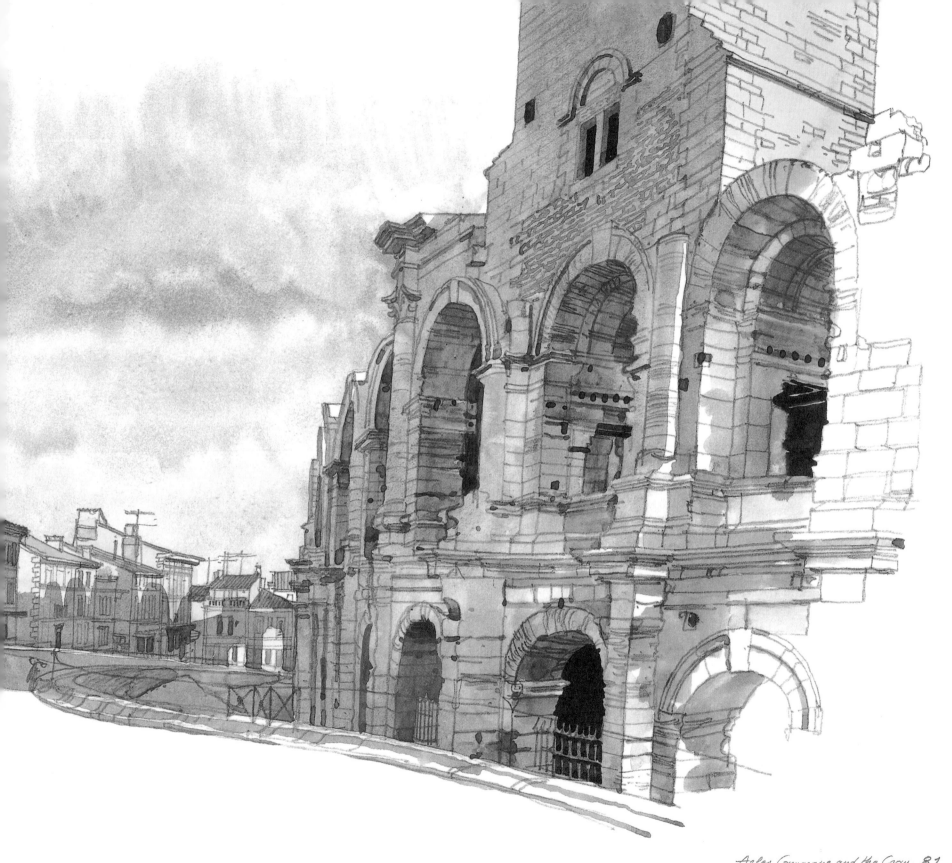

Marseille and the Coast

Despite its great age (2,600 years old), Marseille is modern, dynamic and multi-cultural, and grows visibly younger every day. For a long time, it suffered from a bad reputation as a dirty, poor and dangerous place ruled by the underworld. With one foot in the east and the other in the west, the Phocean city, however, is once again proudly forging a new image for itself, thanks in part to the advent of the Mediterranean high-speed train that links the Canebière to the Champs-Elysées in just three hours, in part to the tram service and also to the launch of the Euromediterranée project. Meanwhile, watched over tenderly by the Virgin Mary, both French and foreigners alike are rediscovering this balcony onto the Mediterranean, all 111 of its 'villages' blessed with an enviable 365 days of sunshine: the Panier district, traditionally the first point of contact for immigrants when finding somewhere else to settle; Roucas-Blanc, a maze of tortuous steep paths and steps; St-Barnabé, beloved of the bourgeois-bohemians; Mazargues, en route to the calanques; l'Estaque, Cézanne's favourite haunt, and many more.

Clichés and literary references abound on every avenue and corner of this city, the second largest in France. Like many other ports, Marseille is a rebel, despite giving its name to Rouget de Lisle's national anthem, and defies definition, asserting its independence fiercely. You cannot hope to even approach a full understanding of this blazing and faintly mad city in the space of a few days, a place full of so many peoples and mingled cultures. Not too far from this—the nation's most multi-ethnic metropolis, long considered a poor relation of Aix-en-Provence—creeks and calanques await you all the way to Cassis. It's nothing less than pure enchantment.

At the end of the 1920s, Blaise Cendrars fell under the spell of La Redonne and its 'circle of blue water like the inner lake of an atoll', transforming it into his 'little Peleponnese'. Can the same still be said about the place? The best way to find out is to go and see for yourself; give in to the inebriating resonance of the undertow at dawn. You'll be amazed.

BOUILLABAISSE

Auctioning off the fish in the old port. Welcome to Poseidon's table!

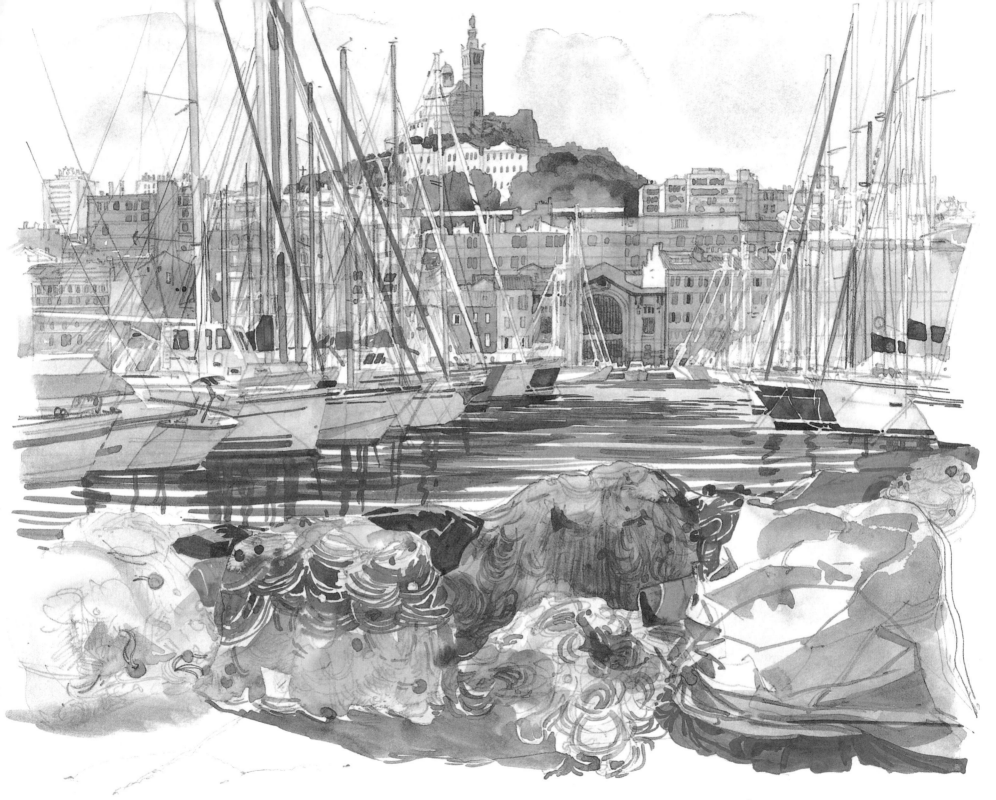

Wander from the old port past lines of colourful boats and
fishing-nets drying in the sun, before climbing up to the Basilique de Notre-Dame-
de-la-Garde. The romance between the 'city of 111 districts' and the sea
has been going on for 2,600 years.

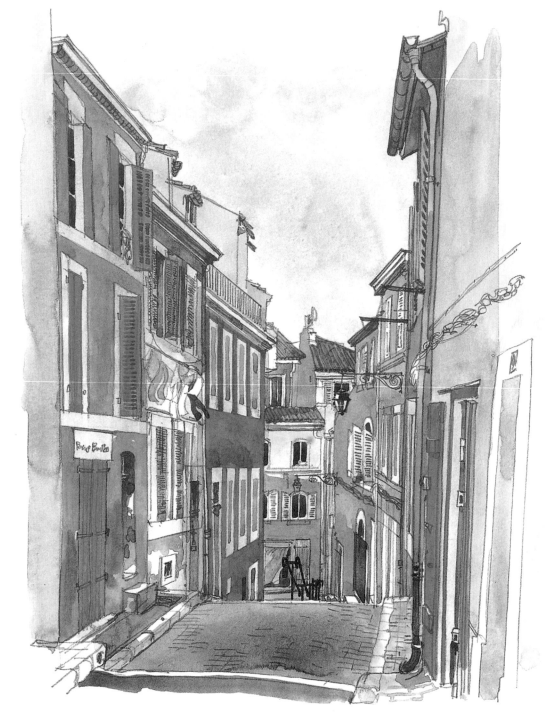

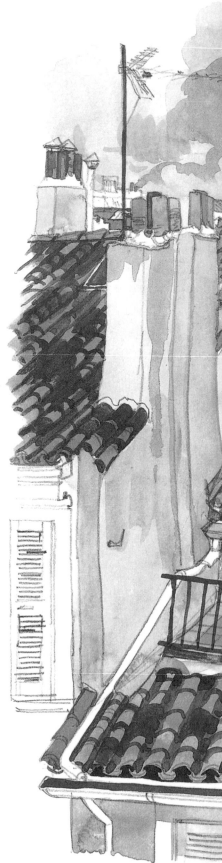

The two Neo-Gothic spires of the Eglise des Réformés seen from a terrace near the Canebière. While proud of its past, France's second-largest city is definitely facing the future, and is on the up after years of decline. Foreigners and French alike are rediscovering its charms, thanks in part to the TGV.

The Panier district next to the old port and the town hall is a vestige of the multiculturalism of old Marseille.
Its increasingly fashionable narrow streets have, over the years, housed Spaniards, Italians, Greeks, Armenians, Comorians and refugees from North Africa.

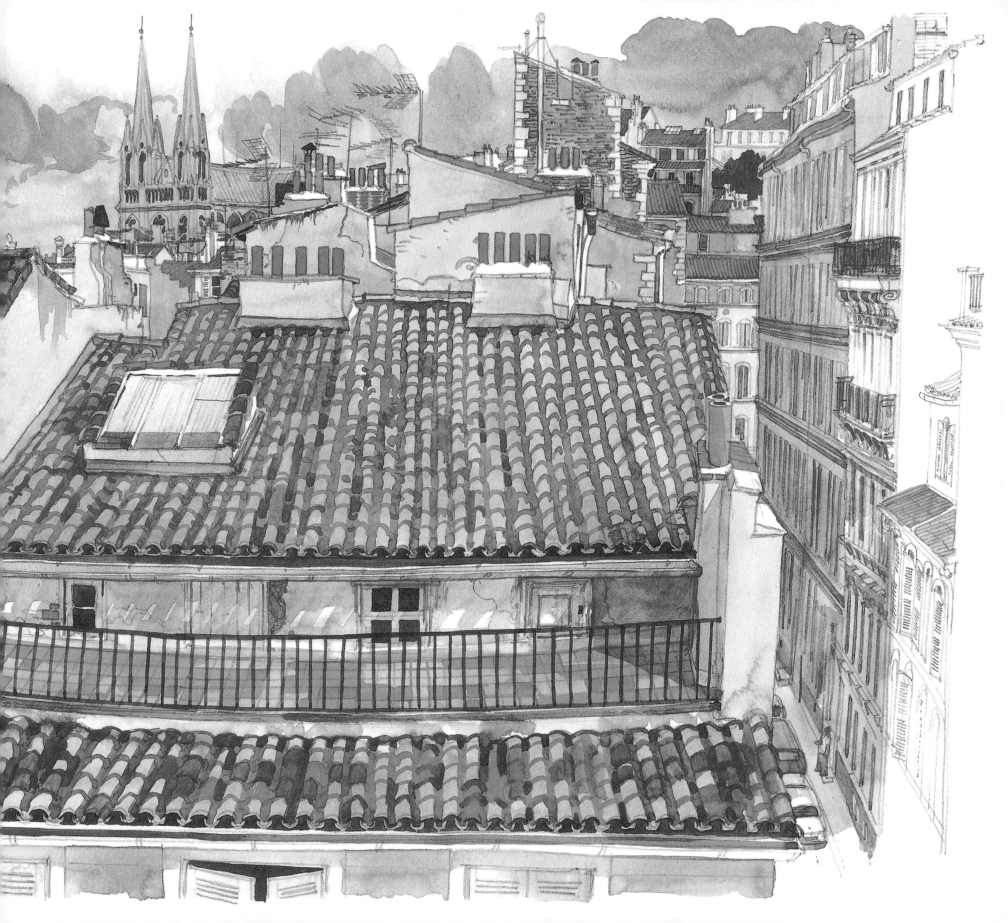

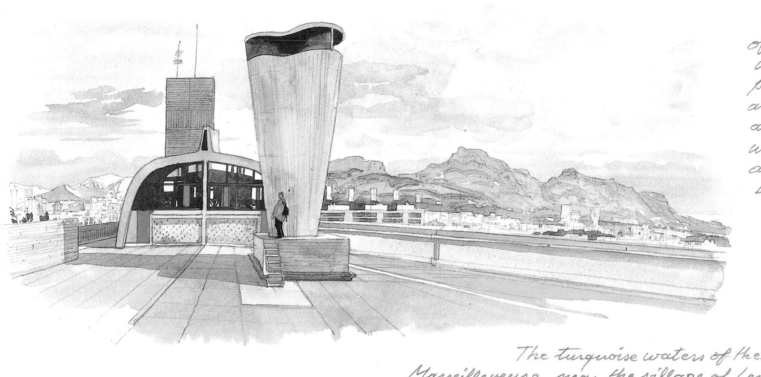

The rooftop terrace
of the Cité Radieuse,
with its swimming
pool, gymnasium
and open-air theatre—
an emblematic
work of modern
architecture by
Le Corbusier.

The turquoise waters of the 'calanques' of
Marseilleveyre, near the village of Les Goudes, with the
island of Maïre in the distance, an ornithological
reserve out of bounds to boats.

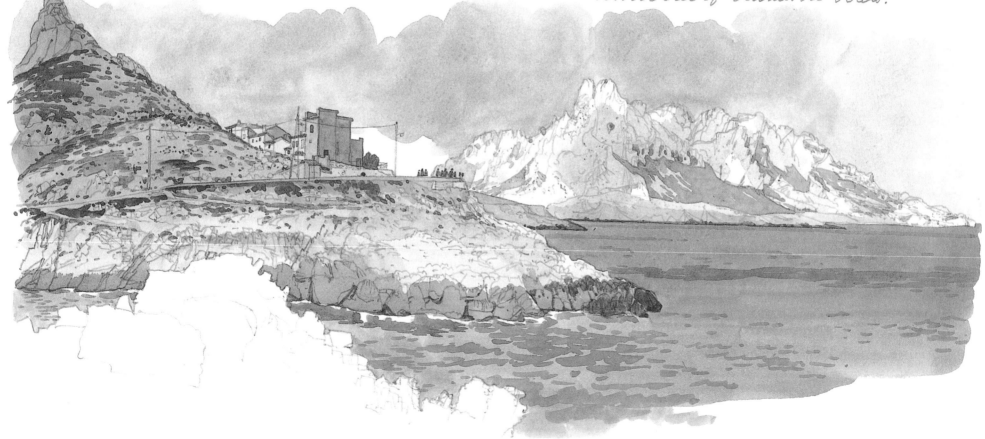

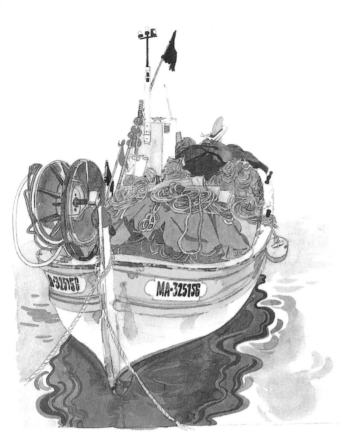

Every Marseillais is a
fisherman at heart and dreams
of owning one of these small huts,
handed down from generation
to generation. The simple lifestyle
that they afford, so close to
nature, inspired the writer
Blaise Cendrars to say that in
such a place 'the mere fact of
existing is pure happiness...'

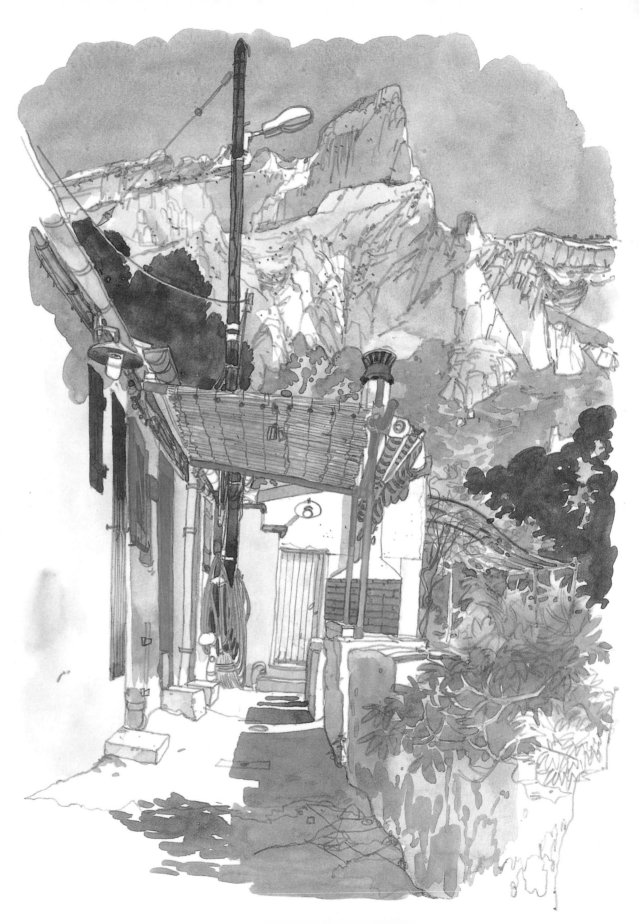

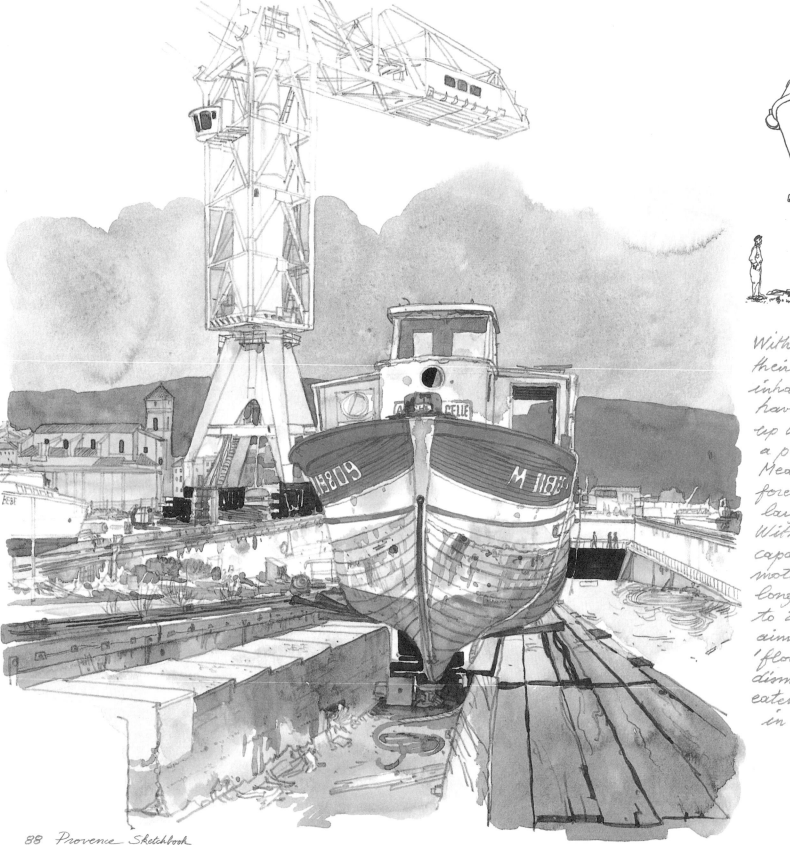

With shipbuilding in
their blood, the
inhabitants of La Ciotat
have recently taken
up with their past, with
a project to create the
Mediterranean's
foremost repair yard for
large pleasure-boats.
With the help of a crane
capable of lifting luxury
motor launches 40-80m
long and weighing up
to 2,000 tons, the town
aims to corner the
'floating palace' market,
dismissing the worm-
eaten skiffs to a lifetime
in the dry docks.

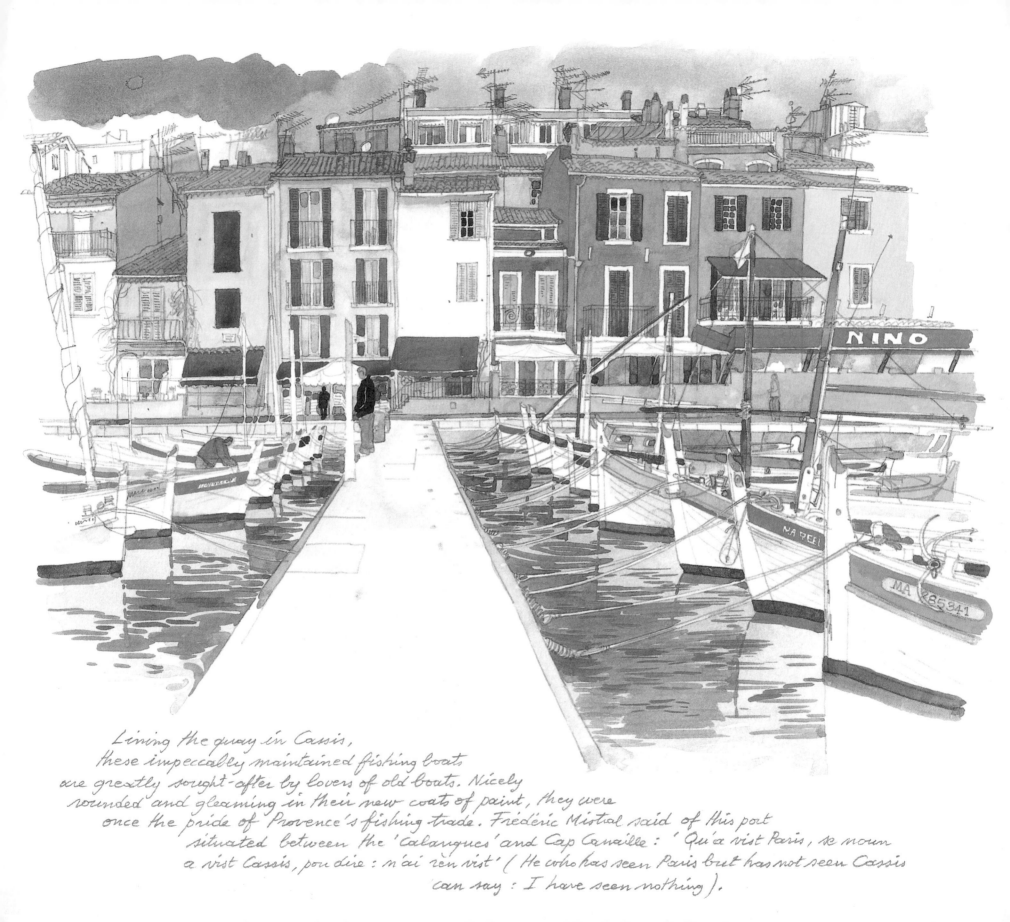

Lining the quay in Cassis,
these impeccably maintained fishing boats
are greatly sought-after by lovers of old boats. Nicely
rounded and gleaming in their new coats of paint, they were
once the pride of Provence's fishing trade. Frédéric Mistral said of this port
situated between the 'Calanques' and Cap Canaille : ' Qu'a vist Paris, se noun
a vist Cassis, pou dire : n'ai rèn vist' (He who has seen Paris but has not seen Cassis
can say : I have seen nothing).

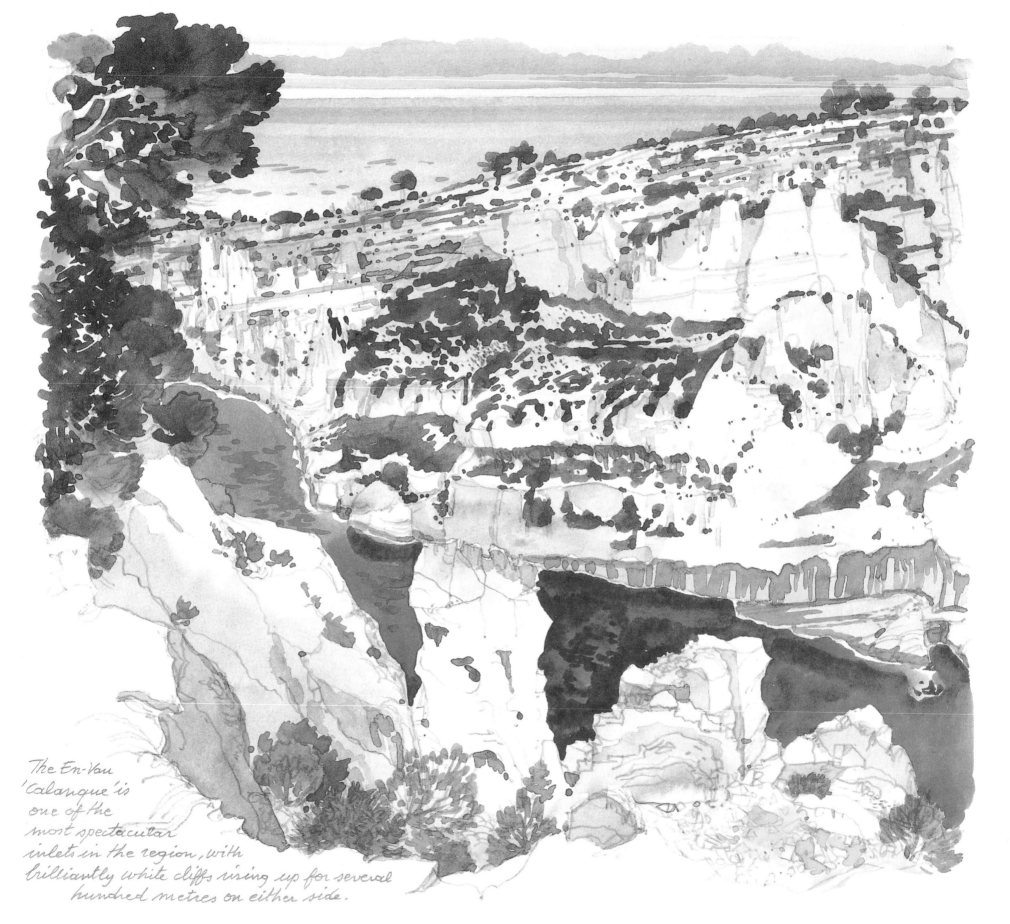

The En-Vau
'Calanque' is
one of the
most spectacular
inlets in the region, with
brilliantly white cliffs rising up for several
hundred metres on either side.

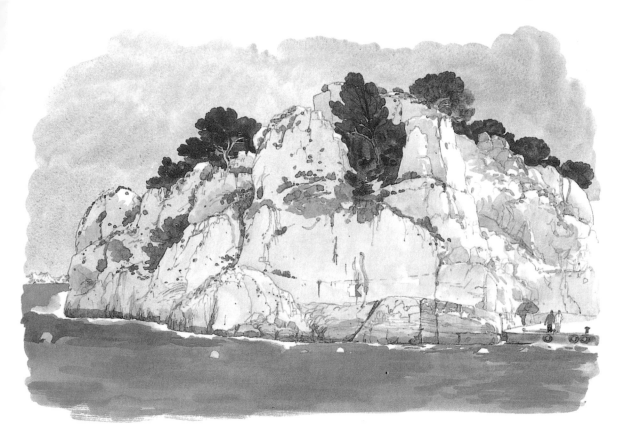

The secluded 'Calanque'
of Niolon and its small port
lie opposite Marseille and
all its ships at anchor.
A 'hidden treasure'
much coveted by divers.

CAMPING LES PINS ⟫

At the heart of the Côte Bleue
stretching from Marseille to
Martigues lies Carry-le-Rouet, famous
for its 'oursinades' (fresh sea urchin festival)
which draw food lovers from throughout the region
on the first three Sundays in February.

A touch of grey
on the Côte
Bleue near
Martigues, on
one of
La Couronne's
beaches.

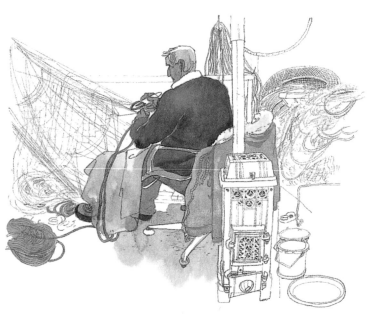

Spreading out on both sides of the Canal de Caronte which links the Étang de Berre to the Mediterranean, Martigues, the 'Venice of Provence', is the last stop for riverboats cruising down the Rhône. Its rows of old fishermen's houses, known as the Miroir aux oiseaux (Birds' Looking-Glass), with their multi-coloured façades reflected in the canal, have enchanted many painters including Delacroix, Corot, Dufy, Picabix, Matisse, Vlaminck and Derain.

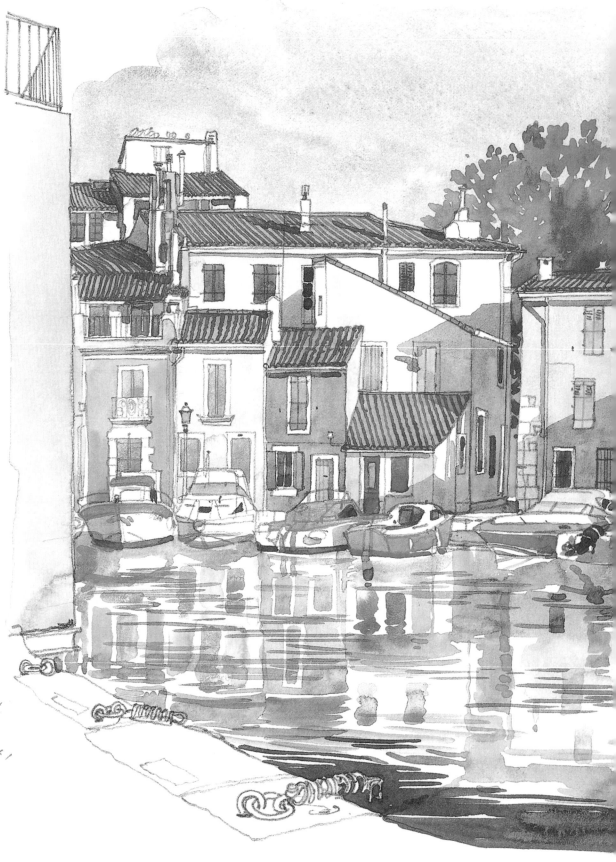

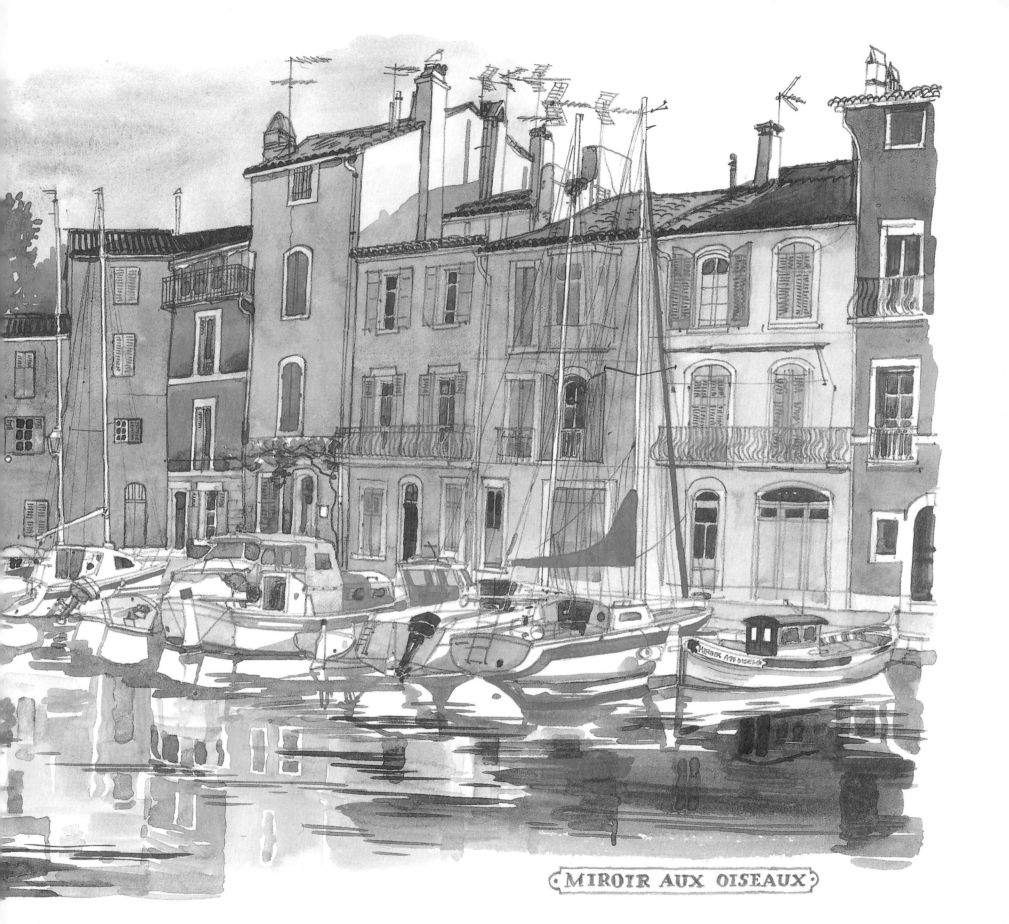

• MIROIR AUX OISEAUX •

A wrought-iron belfry tops the clock tower of the church of Visan, an old village in the Enclave des Papes region of Vaucluse.

Gazetteer

Ideally, this glossary would list all those places that make Provence such a wonder of nature as well as such a delight to all those who live there on a daily basis, who visit it from time to time or who will be visiting it in the near future. If places like Marseille, Aix, Orange, Arles, Avignon, les Baux de Provence and many other towns and villages are not included here, it is because the authors chose to focus on less well known but equally interesting sites—a sort of 'personal favourites' list.

The Alpilles
Lying between the valleys of the Rhône and the Durance, between the plains of the Comtat Venaissin and the Crau, the Alpilles raises its ragged white crests towards the blue sky. Both neighbour and rival of the Luberon, this herb-covered limestone massif is famous for its picturesque villages (Les Baux-de-Provence, Saint-Rémy-de-Provence, Fontvieille, Paradou, Mouriès, Eygalières…), olive groves, pine forests, outstanding ornithological interest, garrigue landscape and vineyards.

Apt
Madame de Sévigné, in a letter to her daughter Madame de Grignan, compares Apt to a jam cauldron. Surrounded as it is by orchards, this Provençal town has, for many centuries, been the capital of crystallised fruit, much sought after by the Avignon popes way back when. Its famous Saturday market also dates back to the Middle Ages.

The bastides of the Pays d'Aix
The 17th- and 18th-century bastides dotted about the countryside around Aix-en-Provence are snatched up for a small fortune nowadays. Once the summer refuge of well-to-do Aixois families, these magnificent homes with their formal French gardens epitomise the Provençal good life.

The Dentelles de Montmirail
These abrupt and jagged crests in the north of the Vaucluse form part of the Baronnies massif, the advance guard of the Alps in the Rhone valley. A haven for ramblers and rock climbers, among such enchantingly-named villages as La Roque-Alric, with its brightly coloured houses overlooking the entire valley; Malaucène, huddled inside its ramparts where boules players get one in or throw alongside a stone bench fully 41.77 m long!; and Bédoin, spread over 9,300 hectares, 6,300 of which are forested…

The calanques
Sormiou, Podestat, Sugiton, La Mounine, Marseilleveyre, En Vau, Port Miou, Port Pin, Mugel, Figuerolles… The calanques are formed from a limestone massif chiselled by erosion which runs for roughly 20 km from south of Marseille to Cassis and La Ciotat—fjord-like inlets with sheer white cliffs plunging straight down into the clear blue waters of the Mediterranean. An all-but-sacred environment perfect for hiking, diving, climbing and bathing.

L'Estaque
It was Paul Cézanne, the inspired precursor of modern painting, who made the name of this little fishing port on the north-western edge of Marseille famous. His mother lived there in a small house and he was a frequent visitor from 1869 to 1890, together with fellow artists such as Renoir, Braque, Derain and Dufy.

Gardanne
Midway between Aix-en-Provence and Marseille, perched on the south-eastern slope of the Captivel hill, and immortalised by Cézanne who spent fifteen months there in 1885 and 1886 with his wife Hortense and his son Paul, Gardanne's intimate and lengthy association with the extraction of lignite from local seams came to a definitive end with the closure of the last mine on 31 January 2003.

Gigondas
Backing onto the Dentelles de Montmirail, this history-laden village in the Vaucluse dominates 1,200 hectares of vineyard that produces close to 5.5 million bottles of internationally recognised Gigondas wines, mostly reds from Grenache Noir, Mourvedre and Syrah grape varieties.

The Îles du Frioul
Facing Marseille, barely 2,000 nautical miles from the Provençal capital, the islands of Pomègues, Ratonneau, If (of high fame thanks to the writer Alexandre Dumas) and Tiboulen make up the Frioul archipelago. Four steep-sided limestone islands alive with outstanding flora and fauna.

Istres
Istres is the fourth-largest town in the Bouches-du-Rhône in terms of surface area (11,372 hectares), bordered by two lakes, the Etang de Berre and the Etang de l'Olivier. Despite this, its historic centre remains a maze of charming narrow lanes and elegant 18th-century town houses. The town is also known for its air base which has the longest runway in Europe (5 km), designated an emergency landing zone for the American space shuttle in case of need.

Manosque
Situated in the Durance plain, with the Alps as a backdrop and the Provençal plain all around, Manosque's population has risen to 20,000 thanks to the Cadarache nuclear research centre, making it the main town in the Alpes-de-Haute-Provence region. Its name, however, remains forever associated with the work of the novelist Jean Giono, who said of his hometown: *Everything that is found here, a hundred other towns in Provence possess: light and sunshine, time-worn roughcast walls, greyish-silver olive trees, cypresses, russet-tinted hillsides; there's nothing exceptional about any of this. What is exceptional, however, is the way in which these various elements are put together. I know of nowhere where the telluric architecture is nobler.*

Martigues
Martigues is the fourth most populous town in the Bouches-de-Rhône (45,000 inhabitants), but nonetheless remains a charming place of canals, quays and bridges, well deserving of its title as the Venice of Provence. Built on the water's edge, at the westernmost part of the Etang de Berre, it is not surprising that many famous artists fell under its charm: Vlaminck, Derain, Dufy…

Miramas-le-Vieux
Firmly rooted on a rocky summit, this lovingly restored small medieval village situated between Salon-de-Provence and Istres overlooks the Etang de Berre and the entire Plaine de la Crau. Among its architectural treasures are a 12th-century castle, the parish church Notre-Dame-de-Beauvezer with its arcaded clock tower and the Chapelle Saint Julien, a masterpiece of Romanesque art. Don't miss out on its famous ice-cream shop, Le Quillé.

Mornas
Mornas lies midway between Bollène and Orange in the northern part of the Vaucluse, and is most famous for its 13th-century fortress which is perched, like a sentinel, way up above on a clifftop—a remarkable exampl ee of feudal military architecture with a double row of defensive walls, moats, watch-towers and a keep that overlooks Mont-Ventoux, the Dentelles de Montmirail and the river Rhône as it flows ever southwards on its journey down to the Mediterranean.

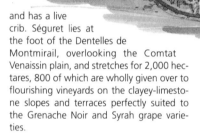

Oppède-le-Vieux

Backed up against the north face of the Petit Luberon, with the Apt plain at its feet, old Oppède (from the Latin, oppidum, meaning citadel) was abandoned in the late 19th century when the peasants moved down to the valley to be closer to their fields. In the 1960s, it began to be restored, its overgrown ruins emerging from decades of ivy and weeds to reveal one of the Luberon's most remarkable sites.

The Plaine de la Crau

Lying between the Massif des Alpilles and the Etang de Berre, the Crau was once the delta of the Durance, and nowadays has two quite distinct parts. The northern part is a fertile, marshy, green and humid plain where the famous Crau hay is grown (the only animal fodder with AOC status). To the south, the steppe-like ecosystem, unique in France, is a perfect sanctuary for nesting birds—120 different species have so far been identified locally, including the crested falcon. It is counted a true paradise for apprentice ornithologists.

Richerenches

Richerenches is unusual both geographically and administratively. Contained within the walls of a 12th-century Templar commandery, the commune of Richerenches, together with those of Valréas, Grillon and Visan, forms part of 'the Papal enclave', a chunk of the Vaucluse within the neighbouring département, the Drôme. Another feature of this place is the 'truffle mass' on the third Sunday each January to honour St Anthony, patron saint of truffle-producers.

Rustrel

Nestling 400 m up on the southern slopes of the Monts de Vaucluse in the Luberon regional nature park, Rustrel is a charming village, complete with an oil-mill museum, looking out over the 'Colorado of Provence', vast ochre quarries spread over an area of 2,800 hectares. The 1930s slump, followed by the Second World War and the boom in chemical colouring agents, put paid to the commercial viability of these sites.

Ste-Baume

In this area, the word for cave is baume. Hence the name of this rocky barrier, 1,147 m long, an important place in the history of Provençal Christianity. Tradition has it that Mary Magdalene, that most famous of sinners, drifted at sea before eventually being washed ashore at Saintes-Maries-de-la-Mer, from where she found her way to a cave in the Ste-Baume massif, and spent the last 33 years of her life in the most perfect solitude. A sacred forest covering 140 hectares of north-facing slopes harbours maple, beech, lime, ash, white oak, aspen, sycamore and ancient yew trees.

Mont Ste-Victoire

Fascinated by this mountain, Paul Cézanne depicted it in over 80 canvases between 1870 and 1906. The town of Aix has created a special 'painters site' in honour of 'la Sainte', where copies of 10 of the most important of these works are displayed. Shortly before his death, Cézanne was struck by lightning on 15 October 1906 while painting on the road to Tholonet, just opposite 'la Sainte'.

Saintes-Maries-de-la-Mer

Every year, in May, thousands of gypsies from all over Europe flock to Saintes-Maries-de-la-Mer to pay homage to their patron saint Sara, the black Madonna. On 24 May, a large procession accompanies her statue, heavily bedecked in jewellery and brightly-coloured skirts, starting from the church of Notre-Dame-de-la-Mer and going right down to the sea. According to ancient legend, the travellers' patron saint was the black servant-girl of Mary Salome, mother of the apostles James and John, and Mary Jacobea, sister of the Virgin, all three of whom were washed ashore at Notre-Dame-de-Ratis, renamed Saintes-Maries-de-la-Mer in their honour.

Salin-de-Giraud

Salt has been extracted in this village on the southeastern side of the Camargue delta, on the right bank of the Grand Rhone, since the late 19th century. The salt marshes in this area cover thousands of hectares and harbour some of the most extraordinary flora and fauna—which is of immense ecological interest. The Etang du Fangassier is France's only breeding ground for the exotic-looking pink flamingos.

Sault

Lovers of lavender should definitely make it a point to stop in Sault, perched on a rocky spur overlooking the valley that lies at the junction of Mont Ventoux, the Monts de Vaucluse and the Albion plateau. The former capital of the county of Sault is one of the major halts on the 'lavender trail' which is approached either from Carpentras through the winding Gorges de la Nesque, or from Vaison-la-Romaine through the Toulourenc Valley. Whichever way taken, the surrounding countryside is painted a striking bluish-purple.

Séguret

This medieval village might be called the Bethlehem of Provence, for on Christmas Eve the midnight mass is said in Provençal and has a live crib. Séguret lies at the foot of the Dentelles de Montmirail, overlooking the Comtat Venaissin plain, and stretches for 2,000 hectares, 800 of which are wholly given over to flourishing vineyards on the clayey-limestone slopes and terraces perfectly suited to the Grenache Noir and Syrah grape varieties.

The Etang de Vaccarès

The jewel of the Camargue, and the largest lake on this deltaic plain, is an extraordinary stretch of water which in the winter months provides shelter for tens of thousands of birds from northern Europe. Thanks to its status as a national reserve, public access is limited, except for two areas which have been specially adapted for bird-watching: La Capelière and Salin de Badon.

Venasque

Perched on a sheer-faced rocky outcrop and protected by a huge curtain wall classified since 1892, this minute village in the Monts du Vaucluse, a stone's throw from Mont Ventoux, was once, before Carpentras, the capital of the Comtat Venaissin (which owes its name to it). Thanks to its church, its 6th-century baptistry, its fountains and public wash-places, it qualifies as one of the most beautiful villages in France.

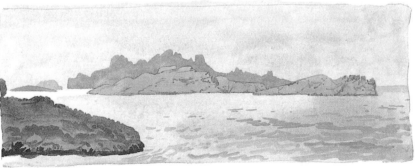

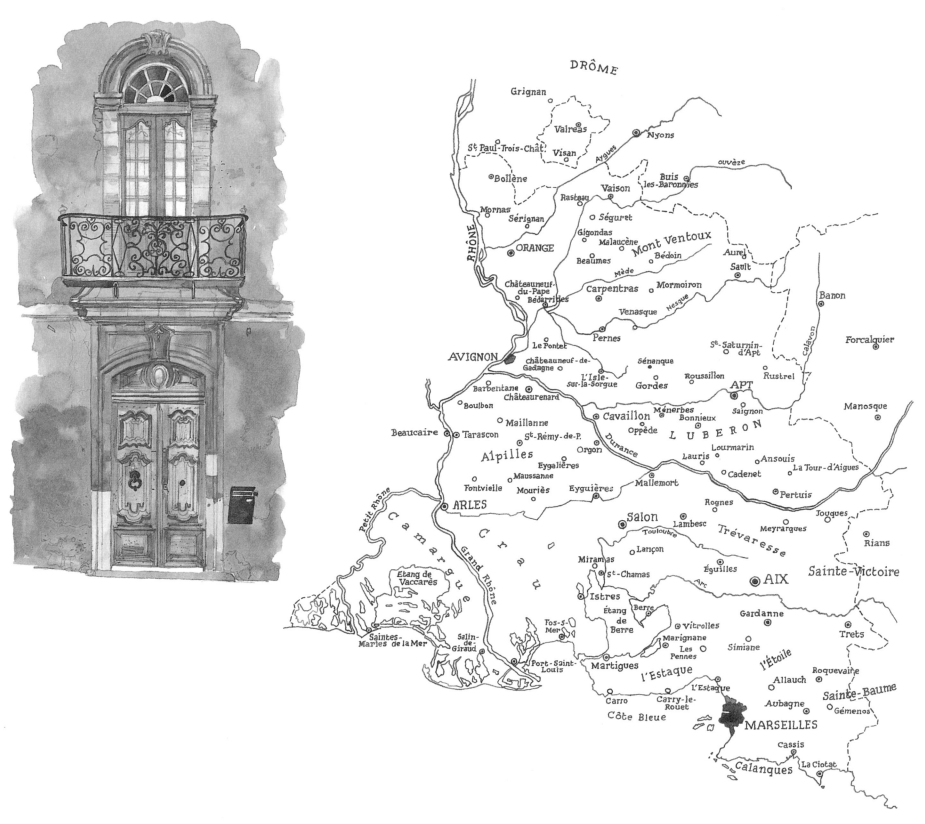

DRÔME

Grignan

Valréas Nyons
St Paul-Trois-Chât. Visan ouvèze
 Aygues
Bollène Buis
 Vaison les-Baronnies
 Rasteau
Mornas Séguret
RHÔNE Sérignan
 Gigondas
 Malaucène Mont Ventoux
 ORANGE Beaumes Bédoin Aurel
 Mède Sault
 Châteauneuf-
 du-Pape Carpentras Mormoiron
 Bédarrides
 Venasque Nesque Banon
 Pernes
 Le Pontet St-Saturnin-
AVIGNON d'Apt Forcalquier
 châteauneuf-de- Sénanque
 Gadagne L'Isle- Gordes Roussillon Rustrel
 Barbentane sur-la-Sorgue APT
 Châteaurenard Ménerbes Manosque
 Boulbon Cavaillon Bonnieux Saignon
 Maillanne Oppède LUBERON
Beaucaire Tarascon St-Rémy-de-P. Lourmarin
 Orgon Durance Lauris Ansouis
 Alpilles Eygalières La Tour-d'Aigues
 Maussanne Cadenet Pertuis
 Fontvieille Mouriès Eyguières Mallemort
 Rognes
 ARLES Salon Lambesc Trévaresse Jouques
 Touloubre Meyrargues
 Camargue Crau Lançon Rians
 Miramas
 Étang de St-Chamas Éguilles AIX Sainte-Victoire
 Vaccarès Grand Arc
 Rhône Istres Étang
 Fos-s- de Berre Vitrolles Gardanne
Saintes- Salin- Mer Berre Marignane Trets
Maries de la Mer de-Giraud Les Simiane l'Étoile
 Martigues Pennes Roquevaire
 Port-Saint- l'Estaque Allauch
 Louis l'Estaque Sainte-Baume
 Carro Carry-le- Aubagne Gémenos
 Rouet MARSEILLES
 Côte Bleue Cassis
 Calanques La Ciotat

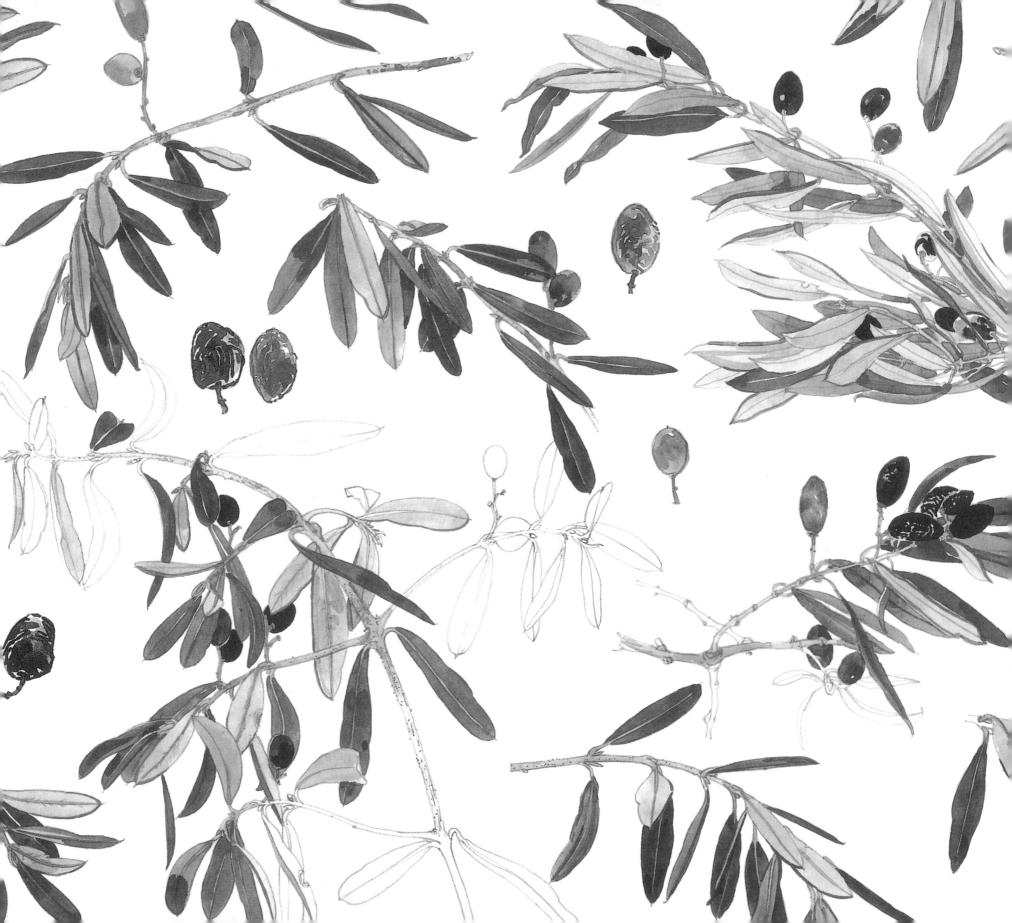